HOW
TO
KNOW
AMERICAN
FOLK
ART

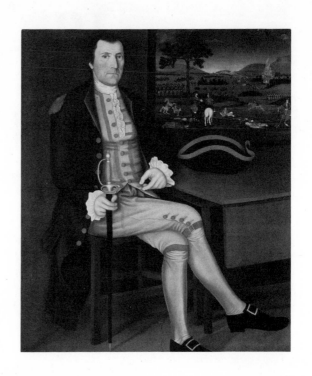

E. P. DUTTON *New York*

HOW
TO
KNOW
AMERICAN
FOLK
ART

Eleven Experts
Discuss Many Aspects
of the Field

Edited by
Ruth Andrews

Library of Congress Catalog Card Number: 77–72039
ISBN: 0–525–47460–9

Published simultaneously in Canada by Clarke, Irwin & Company Limited, Toronto and Vancouver.

10 9 8 7 6 5 4 3 2 1

First Edition

Designed by The Etheredges

CONTENTS

COLOR
ILLUSTRATIONS

(Follow page 76)

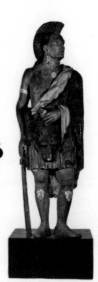

ACKNOWLEDGMENTS

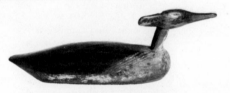

Grateful thanks are due the following individuals and institutions whose gracious cooperation has made this book possible.

Abby Aldrich Rockefeller
 Folk Art Collection,
 Williamsburg, Virginia
The Americana Collection
 of Donaldson, Lufkin &
 Jenrette, Inc., New York
Mr. and Mrs. Edwin Braman
Bridgeport Public Library,
 Bridgeport, Connecticut
Mrs. Warren J. Broderick
Mr. and Mrs. Stephen C.
 Clark, Jr.
Mr. and Mrs. Ridgely W. Cook
The Denver Art Museum,
 Denver, Colorado
James Eakle
Fairmount Park Commission,
 Philadelphia, Pennsylvania
Farm Security Administration,
 Library of Congress,
 Washington, D.C.
Howard and Catherine Feldman
Forbes Library, Northampton,
 Massachusetts
Frederick Fried Archives,
 New York
Edgar William and Bernice
 Chrysler Garbisch
Greenfield Village and
 Henry Ford Museum,
 Dearborn, Michigan
Julie Hall
George Hammell
Herbert W. Hemphill, Jr.
The Henry Francis du Pont
 Winterthur Museum,
 Winterthur, Delaware
Heritage Plantation of
 Sandwich, Massachusetts
Historical Society
 of Berks County,
 Reading, Pennsylvania
Index of American Design,
 National Gallery of Art,
 Washington, D.C.
Sidney Janis Gallery, New York

Mrs. Jacob M. Kaplan
Kelter-Malcé Antiques,
 New York
Lansingburgh Historical
 Society, Troy, New York
Jean and Howard Lipman
Maryland Historical Society,
 Baltimore, Maryland
The Metropolitan Museum
 of Art, New York
Moravian Museum of
 Bethlehem, Bethlehem,
 Pennsylvania
National Gallery of Art,
 Washington, D.C.
Elise Macy Nelson
New Haven Colony Historical
 Society, New Haven,
 Connecticut
The New York Public Library,
 New York
New York State Historical
 Association, Cooperstown,
 New York
Old Sturbridge Village,
 Sturbridge, Massachusetts
George E. Schoellkopf Gallery,
 New York
Sotheby Parke Bernet, New
 York
Shelburne Museum, Inc.,
 Shelburne, Vermont
Kenneth E. Tuttle,
 Richmond, Maine
Van Alstyne
 Folk Art Collection,
 Smithsonian Institution,
 Washington, D.C.
Washington-Custis-Lee
 Collection, Washington
 and Lee University,
 Lexington, Virginia
Whitney Museum of American
 Art, New York
George F. Wick
Several Private Collectors

PREFACE

by

Ruth Andrews

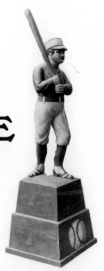

This book grew out of a course in American folk art that I gave at New York University for several years. The objective of the course was to teach collectors, dealers, and students how to look at and what to look for in our folk art. In an effort to clarify and define American folk art each session featured a specialist—many of whom are contributors to this book—who had diligently researched one particular area. Of necessity the book has had to be selective: to give sufficient background for the most prominent aspects of folk art has been the goal. Thus the frontier art of the Southwest created by the Spaniards who settled there, and the cohesive, European-derived work of the Pennsylvania Germans are both included because these two groups represent the strongest expression of ethnic and religious beliefs. American Indian art is not covered because it is indigenous to our country and accepted as a complete division of creative importance on its own. Regional folk art, which is surfacing with greater energy each year, has also been left for another book.

American folk art is the personal expression of untutored creators, and as such might be termed idiosyncratic. The eccentricity of viewpoint or personal artistic drive that added aesthetic value to objects made for utilitarian, decorative, religious, and economic use, or perhaps just to while away time, are seen today as expressions of beauty, originality, vitality, and native artistry. These works compel our interest and attention. In essence, this is what attracted various specialists—such as the contributors to this book—to the fields they have explored and continue to explore, for new discoveries and insights about our folk art are constantly being made. Like the folk artists, the specialists, too, are highly individualistic and sometimes idiosyncratic in their approach to the areas in which they work.

This book is exceptionally fortunate in having as contributors so many of the great people working in the American folk art field. Knowing the integrity and the intensity of their feelings about their

work, I am most appreciative of the time and courtesy they have shown in this endeavor. Most already have made an indelible mark: Louis C. Jones, Director-Emeritus of the New York State Historical Association, a pioneer researcher and educator for forty years; Adele Earnest, for more than thirty years consultant to museums and collectors, author of a fine book on decoys and a founder of the Museum of American Folk Art in New York; Mary Black, former Director of the Abby Aldrich Rockefeller Collection at Williamsburg and the Museum of American Folk Art, now Curator of Painting and Sculpture at The New-York Historical Society, co-author with Jean Lipman of *American Folk Painting* and author of numerous monographs, articles, and museum catalogues; Pastor Frederick S. Weiser, foremost expert on Fraktur and editor of publications for The Pennsylvania German Society; photographer Ann Parker and writer Avon Neal, noted for their gravestone rubbings and lore, and for their book, *Ephemeral Folk Figures*; Frederick Fried, renowned historian of cigar-store Indians, show figures, and carousels and author of two definitive books on works in wood; Jonathan Holstein, who first saw the relationship between pieced quilts and contemporary American art and who was responsible with Gail van der Hoof for the first exhibition of American quilts held in a major museum, the Whitney Museum of American Art, New York, in 1971; Robert Bishop, the encyclopedic documentor of American furniture, folk sculpture, and quilts who almost yearly adds to our knowledge and visual appreciation of works in these areas—and now the director of the Museum of American Folk Art, New York; William C. Ketchum, Jr., a thorough and loving delver into the makers of pottery and porcelain, author of detailed books on those subjects; Robert J. Stroessner, Curator, New World Department, The Denver Art Museum and an authority on folk art of the Southwest; and M. J.

Gladstone, former Director, Museum of American Folk Art and author of a book that describes the folk sculpture found on our city streets and country roads.

It was in 1931 that Holger Cahill organized an exhibition of American folk sculpture at The Newark Museum. For that catalogue he wrote a perceptive commentary that included the following: ". . . folk art in its truest sense . . . is an expression of the common people and not an expression of a small cultured class. Folk art usually has not much to do with the fashionable art of its period. It is never the product of art movements, but comes out of craft traditions, plus that personal something of the rare craftsman who is an artist by nature if not by training. This art is based not on measurements or calculations but on feeling, and it rarely fits in with the standards of realism. It goes straight to the fundamentals of art—rhythm, design, balance, proportion, which the folk artist feels instinctively." It is now forty-six years later; research has identified many artists and works but no one to my knowledge has improved on this succinct statement.

The imagination, energy, spontaneity, contrariness, and intuitiveness of our folk artists are uniquely American and give us much delight. The surging interest in this art form owes a big debt to the American artists who first responded to it early in this century. Recognition should be given also to a prominent dealer, Edith Gregor Halpert, owner of The Downtown Gallery in New York. During the 1920s Mrs. Halpert bought folk paintings, cigar-store Indians, weathervanes and other objects that she called "ancestors" of the contemporary American artists she showed in her gallery. It was Edith Halpert's enthusiasm for American folk art that excited the interest of Mrs. John D. Rockefeller, Jr., in 1929 and led her to purchase the works that became the nucleus of the Abby Aldrich Rockefeller Folk Art Collection now at Williamsburg, Virginia.

I would like to thank each of the contributors and also Tamara E. Wasserman, Howard A. Feldman, H. B. Bradley Smith, George F. Wick, Mrs. J. M. Kaplan, Ralph Esmerian, Bert Hemphill, David Pettigrew, and Nancy Druckman without whose help this book would have been incomplete. And a special thanks to Ann Parker for her great generosity.

To Mary Black, a very talented lady and great friend, I am indebted for the initial contact that through the years led to this book; and to Cyril I. Nelson my gratitude for his patience and courtesy. My appreciation also to Harriet Serenkin and Marjorie Griffiths who attended various seminars at NYU and consented to comment on and proof the book.

RUTH ANDREWS

INTRODUCTION

by

Louis C. Jones

The newcomer to the field of American folk art is understandably confused by a cacophony of definitions. One must remember that definition follows usage and that in this instance scholars, museum curators and directors, dealers, and collectors have all had their input. Confusing to the issue are old, long-established, European concepts of folk art that, in many ways, differ from America's— though it is well to remember that, even in Europe, strong differences exist as to what is and what is not folk art.

A major museum collection in the United States may contain ships' figureheads (fig. 1), schoolgirl watercolors, paintings by itinerant artists, unusual ceramics, quilts, needlework pictures, tavern signs, weathervanes, and political banners (fig. 2)—all of it called American folk art. At a major antiques show, one dealer may advertise his Frakturs as folk art, another, his Shaker chairs. An important recent exhibition of American folk art emphasized painted furniture. The people who make the decisions to call these objects folk art are constantly expanding and contracting the definition. The term *folk art* is like a great circus tent under which a variety of acts are simultaneously taking place. The variety makes generalizations very dangerous; too often writers are thinking only about paintings or only about carvings when they utter their dicta.

What then do these heterogeneous objects have in common? First of all, they are outside the fine arts tradition. The artists who created them were never disciplined to the concepts of art that grew out of the Italian Renaissance, though they may have had a bowing acquaintance with such ideas as perspective. Nor were they trained to copy the Greek and Roman sculptures that the seventeenth century rediscovered. Often, but by no means always, the art derives from a craft tradition to which it adds aesthetic qualities that grow out of some hidden inner drive of the artist. It comprises simple objects made for a public that had few firm convictions about art and even less experience with the fine arts traditions.

That public, however, was often the most sophisticated in its time and place. One of the wealthiest and most knowing of the farmers in an area might hire a very naïve painter to limn portraits of the farmer and his wife. American folk art reflects the artist who created the work and, even more, the public for which it was created.

1. Head of Ceres. Attributed to Simeon Skillin, Jr. c. 1800. Wood, polychromed. H. 24″. (*New York State Historical Association*)

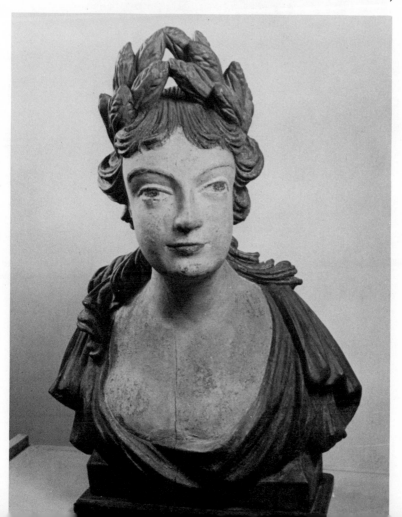

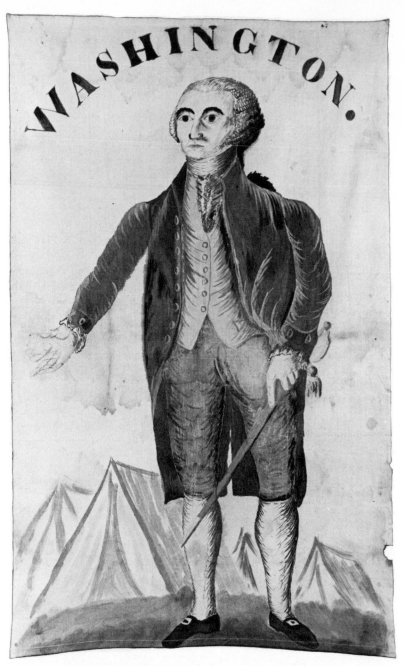

2. Washington banner. Found in West Virginia. 1800–1825.
Oil on cloth. 53¾″ × 34¼″. (*New York State Historical Association*)

Another common characteristic of these heterogeneous objects is a tendency toward strong design; indeed, this is one of the criteria by which folk art is to be judged. It tends to exhibit rhythms of all kinds with an infinite range of variations whether in a paper cutting, a quilt, a portrait, or the skirt on a wooden Indian. Colors, used to brighten life and to drive out monotony, tend to be unmixed and lacking in shading and nuance. And the key tends to be simplicity rather than sophistication, directness rather than subtlety.

There are gradations of quality in folk art as in every other kind of art. In the beginning it may all appear to be of a similar cast, but the more you see of the objects themselves, the more they fall into their levels of quality. Aesthetic values of a given body of material may be seen variously by different specialists, but a surprisingly firm consensus emerges if the specialists share years of involved experience. And the only way to gain that experience is to look at actual objects (not books, not slides, but the real thing) at every opportunity—in museums, in galleries, in private collections. As one looks it becomes increasingly evident that besides the aesthetic pleasure they give these are documents out of the past that call for analysis and careful reading. So read, they enlighten us as to thousands of facets of life as it has been lived in this country.

One should be warned not to be concerned over the adjectives used to describe the body of work: folk, primitive, naïve, country, nonacademic. Although these words have had specific meaning for individual writers, there is too little general agreement to set up reliable definitions. There has always been a certain resistance to the word *folk* in this country. Forty years ago I observed this resistance in relation to folklore. Some of our countrymen will tell you, with a touch of hauteur, that "folk refers only to peasants and we don't have any peasants." Rather than argue that point, I call to mind Alice Winchester's observation in her superb introduction to *The Flowering of American Folk Art* (1974) that we use the

word *folks* all the time—"my folks, your folks." "Our Folks' Art" might be a happy solution but it is clumsy, and at last people are beginning to know what to expect when we say "American folk art." It really doesn't matter what we call it; it exists item by item and should be enjoyed for its own sake. We should not casually pass over that point, for folk art is to be enjoyed; it was created to make life less dreary and it still so functions.

Comparing American and European folk art is useful and emphasizes the difference between Pennsylvania German folk arts and those in the rest of the country. Pennsylvania German folk art was transferred from European traditions with only minor modifications. In the rest of the country the butter mold was about the only common household implement that was consistently decorated. Small wonder that Crèvecoeur commented that in America beauty was often subordinate to function. In the European tradition, whenever possible in the handcraft age, household implements of all sorts were carved and decorated. The European decorator of furniture, whether painter or carver, worked within a long-established local tradition, seeking to achieve excellence as it was locally recognized, but not trying to imprint his own personality on his work. This is one of the great differences between the European and the American traditions: the American folk artist was—and is—very much of an individualist, anxious to create an art form reflecting himself and his uniqueness. He put his trademark on what he did by means of his personal style. Anonymity was the accepted norm in Europe—to discover the artist, to understand his uniqueness, is seen as a desideratum by American scholars.

It would be interesting to know what folk arts the early settlers brought with them and to what extent the field had developed on this side of the Atlantic before the Revolution. We have some inklings, but no thorough study of the question has been made so

far as I am aware. We don't know what has been lost or destroyed
with the changes of taste. Moreover, Americans have always been
a peripatetic people, and every time a household moved much was
discarded. The order in which objects and traditions of objects
came to these shores is obscure, but by 1776 we know that there
was a well-established body of primitive portraits. Some of the
artists had studied briefly under the aegis of the few European-
trained artists who had emigrated; others were self-taught, assisted
by the careful study of European prints. There were landscapes
painted on some walls and overmantels. Indeed, one of the latter,
the 1735 Van Bergen overmantel (plate 1) from Catskill, New
York, is not only one of the earliest specific American landscapes,
but our earliest genre, our earliest conversation piece: a complex
of twenty portraits of the family Van Bergen, their slaves, servants,
and Indian neighbors. It is a telling example of how a folk painting
can be an invaluable social and historic document.

Decoy makers and gravestone carvers were our first folk sculp-
tors, but we know that before the Revolution there were also
weathervanes, trade signs, figureheads, and decorative busts. So
the wood-carvers were well entrenched, especially in the Northeast.
Ultimately it may develop that wood carving in Quebec was much
further advanced than in the colonies to the south. The Church in
Quebec had brought in skilled craftsmen to create religious sculp-
ture and in so doing established a strong tradition that spread out
the whole community, encouraging, I suspect, a much higher stand-
ard of popular taste. In the Spanish Southwest, which later would
be part of the United States, religious carvings and paintings were
also well established by this time.

One early form of folk art that has survived in fairly large
numbers from this period and, incidentally, has received very little
notice is the incising on powder horns (fig. 3), both military and

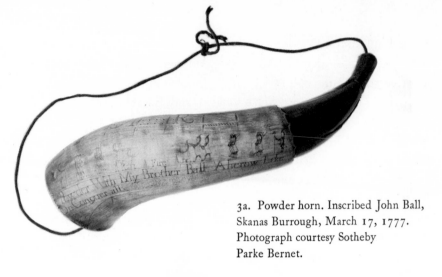

3a. Powder horn. Inscribed John Ball, Skanas Burrough, March 17, 1777. Photograph courtesy Sotheby Parke Bernet.

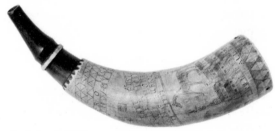

3b. Powder horn. Inscribed Aaron Page, Lake George, July 8, 1758. Photograph courtesy Sotheby Parke Bernet.

domestic. Some early needlework and some decorative ironwork survives, but by and large pre-Revolutionary folk art is scarce. We can only guess at what has been lost.

Once the Revolution was over and the young country had a sense of itself, the folk arts blossomed (fig. 4). One reason was the lack of specialized craftsmen and the profound self-assurance of those who were here. A sign painter who thought himself qualified to paint George III on a tavern sign before the Revolution saw no

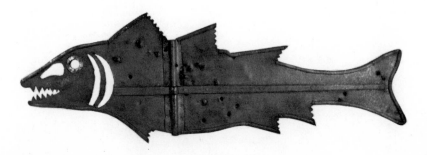

4. Walleyed pike weathervane. Found at Lake Cassyuna, New York.
Early nineteenth century. Sheet iron. L. 59″. Although fish were common
motifs for weathervanes, this was a favorite of the fishermen in Lake Cassyuna.
(*New York State Historical Association*)

reason after the Revolution that he should not also try his hand
at painting the blacksmith's portrait. The countryside must have
teemed with painters who joined other hawkers and walkers and
would travel as far into the wilderness as there were customers
to be painted.

Men and women who had no chance to learn arts and crafts
from a master bought little how-to-do-it books and, following the
directions carefully, were undismayed by their results. They did
reverse paintings on glass, they stenciled floors and walls (fig. 5),
they painted landscapes and fanciful figures (fig. 6). Some of these
books were English in origin, but soon painters like Rufus Porter
were meeting American needs in American terms.

All the arts that had been here before burgeoned and new
forms (fig. 7) and new styles developed. The recently created
symbols of the Republic appeared in every conceivable shape.
Eagles, liberty caps, flags, and the "fine female figure" of Columbia,
representing both the idea and ideals of the United States, were
everywhere: on weathervanes, window shades, courthouses, and the
prows of our ever-hastening ships. These were symbols of a blatant
nationalism and boisterous chauvinism, but they were also symbols

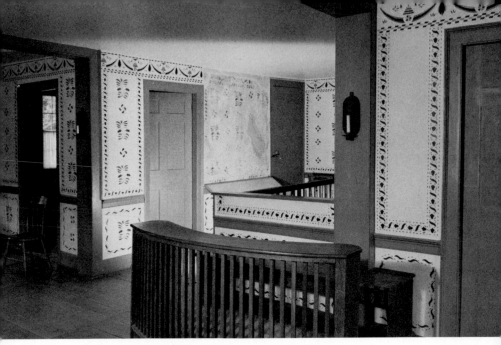

5. Stenciled walls. 1835–1840. Restored at the Bump Tavern,
Farmer's Museum, Cooperstown, New York. Center panel is in original
condition. (*New York State Historical Association*)

6. *Marimaid*. Mary Ann Willson. 1810–1825. Watercolor. 15½″ × 13″.
A striking example of strong design and vigorous color.
(*New York State Historical Association*)

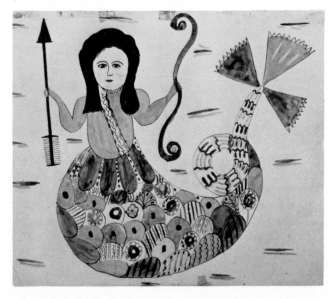

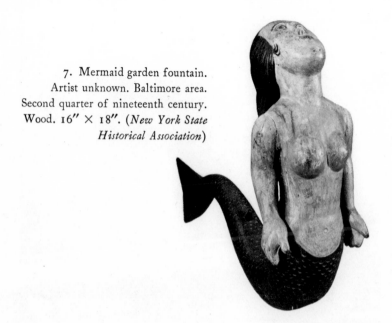

7. Mermaid garden fountain.
Artist unknown. Baltimore area.
Second quarter of nineteenth century.
Wood. 16" × 18". (*New York State
Historical Association*)

of hope, confidence, and profound belief in the Constitution and the future.

As has been frequently observed, the death of Washington in 1799 gave rise to memorial paintings (fig. 8) and needlework, which must have been taught in hundreds of young ladies' seminaries. Other arts were encouraged there such as theorem painting on paper (plate 2) or velvet, and painting of literary or biblical subjects. Meanwhile, as the nineteenth century progressed, the wood-carvers' shops became more and more like factories with large work staffs for growing areas of specialization: designing, shaping, carving, painting. By the time carvers had turned from cigar-store Indians (fig. 9) to circus wagons and carousel figures the workplace was little different from any other factory.

These two developments, schoolgirl arts and commercial carving, raise a valid question: are these works properly included in a collection of American folk art. In the first instance, the amateur

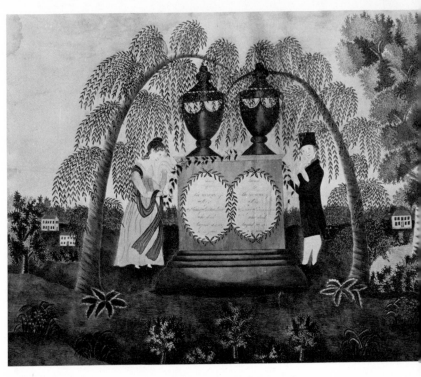

8. *Richardson Memorial*. Harriet Moore. Concord, Massachusetts.
c. 1817. Watercolor in imitation of needlework. 18″ × 24″.
(*New York State Historical Association*)

productions were taught in a classroom, guided by a teacher using, more often than not, a textbook. In the second instance, a group of artisans working on what approached a belt-line basis produced an object that might well have been repeated almost identically the following week. Where is the inner vision of the artist? Where is the continuation of a long craft tradition? One could ask these and other questions about a good many of the types of objects we call folk art.

Yet we may be asking the wrong questions here. For forty years we have said these objects are what we include in American

folk art. They exist. They call for understanding and appreciation. They give pleasure. And it is here that we come closer to the crux of the problem. Do they give pleasure? Is there an aesthetic quality that delights the eye, that stirs the imagination? I am more concerned with whether an object is art than I am with whether or not it is "folk."

In recent years America's awareness of its folk art has increased tremendously on many levels. Whole new areas of interest have developed: paintings on the fences around building sites; far-out constructions christened "Environmentals" by Gregg N. Blasdel; paintings on trucks and campers, and on window screens. We shall find other satisfying folk expressions in the years ahead. The shift of our academic artists away from representation and the Renaissance tradition will help us to see the work of the naïve artist with new eyes.

The great need is for young scholars of the next generation who will bring discipline to a field that now is full of guesswork and

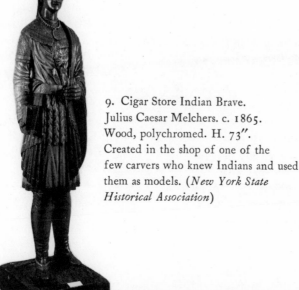

9. Cigar Store Indian Brave.
Julius Caesar Melchers. c. 1865.
Wood, polychromed. H. 73".
Created in the shop of one of the
few carvers who knew Indians and used
them as models. (*New York State
Historical Association*)

enthusiasm but far too few solid facts. We need answers to such problems as the parallel development of our folk and academic art, the identification of more and more of our anonymous artists; and in-depth studies of our living folk artists may be applicable to those of the earlier generations. One could raise questions and offer problems endlessly, and one can only hope that this volume will encourage the needed scholarship. The first step is to look thoughtfully, appreciatively, at the folk art itself.

FURTHER READING

BISHOP, ROBERT. *American Folk Sculpture*. New York: E. P. Dutton & Co., 1974.

BLACK, MARY, and LIPMAN, JEAN. *American Folk Painting*. New York: Clarkson N. Potter, Inc., 1966.

CAHILL, HOLGER. *American Primitive Paintings* (exhibition catalogue). Newark, N.J.: The Newark Museum, 1930.

———. *American Folk Sculpture: The Work of Eighteenth and Nineteenth Century Craftsmen* (exhibition catalogue). Newark, N.J.: The Newark Museum, 1931.

———. Introduction to *American Folk Art, the Art of the Common Man in America 1750–1900*. New York: W. W. Norton & Co., 1932.

FRIED, FREDERICK. *Artists in Wood*. New York: Clarkson N. Potter, 1970.

HEMPHILL, HERBERT W., JR., and WEISSMAN, JULIA. *Twentieth-Century American Folk Art and Artists*. New York: E. P. Dutton & Co., 1974.

JONES, AGNES HALSEY, and JONES, LOUIS C. *New-Found Folk Art of the Young Republic*. Cooperstown, N.Y.: New York State Historical Association, 1960.

LIPMAN, JEAN. *American Primitive Painting*. New York: Oxford University Press, 1942. Reprint. New York: Dover Publications, 1972.

———, and WINCHESTER, ALICE. *The Flowering of American Folk Art (1776–1876)*. New York: The Viking Press, 1974.

LITTLE, NINA FLETCHER. *Country Arts in Early American Homes*. New York: Dutton Paperbacks, 1975.

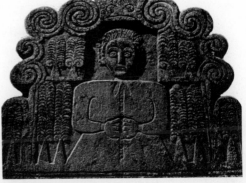

EARLY
NEW
ENGLAND
GRAVESTONES

by

Avon Neal

Photographs by

Ann Parker

One of the earliest American folk art forms was the common grave-stone. When the first settlers came to this country they brought with them a wealth of European traditions, including the age-old custom of commemorating their dead with stone-graven images. This custom, practiced by mostly self-trained artists from the first difficult years in the seventeenth century until shortly after the turn of the nineteenth century, has left a legacy of artistically

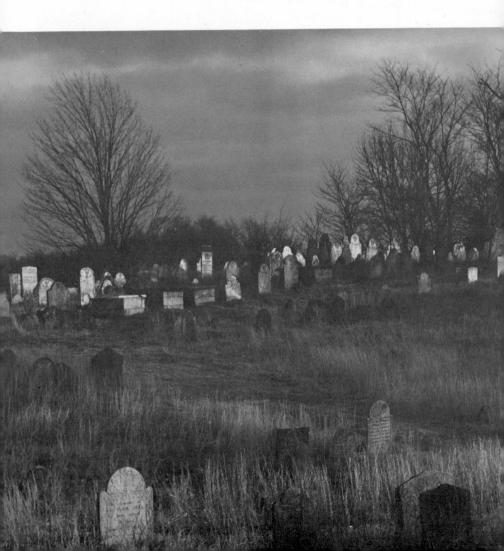

decorated slabs of slate, marble, and sandstone that are now recognized as a unique national heritage. Collectively, they constitute the largest body of creative stone sculpture from the Colonial period. Many fine examples of the gravestone-carver's art have been lost to the ravages of time and the elements, but countless others have survived and can still be found in literally hundreds of historic burying grounds of early New England (fig. 10).

10. Autumn in the Old Burying Ground, Norwichtown, Connecticut.

The men who fashioned America's first gravestones gradually developed their own singular styles. They worked within those styles with only slight variations throughout a lifetime of dedicated carving that, in some instances, lasted more than half a century. Carving with the simplest of tools—mallets, chisels, and grinding stones—these native artists managed to convey an astonishing variety of pictorial images, reflecting the attitudes of their time and reaching beyond them in vision and originality. The early stonecarvers were farmers, blacksmiths, cobblers, and surveyors. There were even sailors who made gravestones during tedious ocean voyages. All these were men who were accustomed to working with their hands and could turn to the stonecutter's trade as the occasion demanded, creating memorials for bereaved friends and neighbors.

11. Detail of gravestone of Pompey Brenton, a slave. Newport, Rhode Island. 1772. Slate. Cut by John Stevens III.

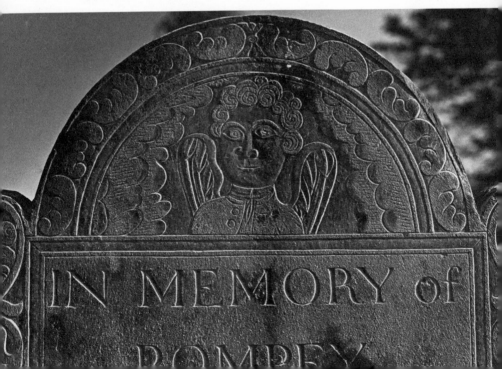

At first stonecutting was only a spare-time occupation, but as villages prospered and populations increased some of these men were able to support themselves full-time as gravestone-carvers. It was not long until shops were thriving and entire families of workmen with their apprenticed sons followed the stonecutter's trade. In a few instances, the most notable being Newport's original John Stevens Shop, which produced some of Rhode Island's most beautiful gravestones (fig. 11), a business remained in the same family for several generations.

Considering the problems in transporting heavy objects any great distance, it was both sensible and practical to use stone from local quarries. Therefore, stonecutters often settled in areas where appropriate materials such as good quality sandstone, schist, slate, and marble were readily available. Generally, the kind of stone available determined the designs that could be most conveniently carved. The coarser sandstones and schist lent themselves to figures sculpted in bold relief (fig. 12) whereas close-grained white marble and layered slate were best suited to finely incised patterns and delicate lettering. Slate was by far the most receptive of all stones to the chisel's most subtle detailing (plate 3). As the result of close harmony between man and material—idea adapted to stone— a gravestone-carver's individual style became his trademark.

Initially, seventeenth- and eighteenth-century memorial markers, with their neatly carved vital statistics and symbols of death and resurrection, were strongly influenced by the work of English stonecutters. As time went by, a distinct character developed, a character strictly American and obviously a departure from what had been created before.

Both secular and religious attitudes of the time were reflected in gravestone art. As life in the Colonies became less severe the awful starkness characteristic of pre-Revolutionary gravestones began to disappear from the imagery portrayed on their embellished

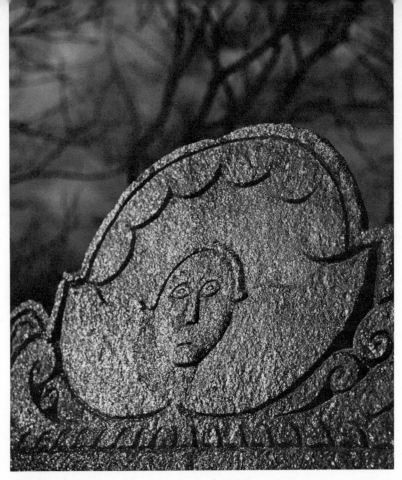

12. Detail of eighteenth-century gravestone showing bold carving. Commonly found in Norwichtown, Connecticut, area.

surfaces. Fashions changed not only in dress, political thought, architecture, and life-styles in general, but in grave monuments as well. Grinning skulls and hollow-eyed death's-heads (plate 4) gradually gave way to cherubs and gentle angels with feathery wings (fig. 13). There was a proliferation of whimsical figures (fig. 14) that can only be described as primitive attempts at portraiture. Most stone portraits were little more than naïve renderings

13. Gravestone of Jedediah Aylesworth. Arlington, Vermont. 1795. Marble.

memento mori

IN MEMORY OF
Mr Jedediah Aylesworth Son of Mr Abel
& Mrs Freelove Aylesworth of Arlington
Who died March the 18th AD 1795
Aged 16 Years 6 Months & 9 Days

This youth tho Young was lov'd by all
By old & young by great & small
His generous soul his obliging way
Among his his acquaintance bore their sway
Death with his hand ere long bow'd his head

14. Detail of gravestone of Deacon Abner Stow and Mary Stow. Grafton, Massachusetts. 1786. Slate.

that, no doubt, were barely recognizable to the families and friends of the illustrious personages they were supposed to portray. In the hands of a few master craftsmen, however, some of these portraits achieved genuine likenesses. The amiably-visaged, periwigged bust of Nathaniel Rogers of Ipswich, Massachusetts, dated 1755 (fig. 15), to cite one example, is representative of gravestone sculpture at its best.

Contrary to popular belief, the Puritans were not without some forms of decorative art. The majority of a stonecutter's work was strictly utilitarian but gravestone carving was one of the few areas in which an artist was free to express himself creatively. Then as now, ostentatiousness played an important role in lavish funerary proceedings and in the manufacture of finely wrought gravestones as well.

In Colonial times a man's funeral could cost as much as he

15. Detail of gravestone of Reverend Nathaniel Rogers. Ipswich, Massachusetts. 1775. Sandstone.

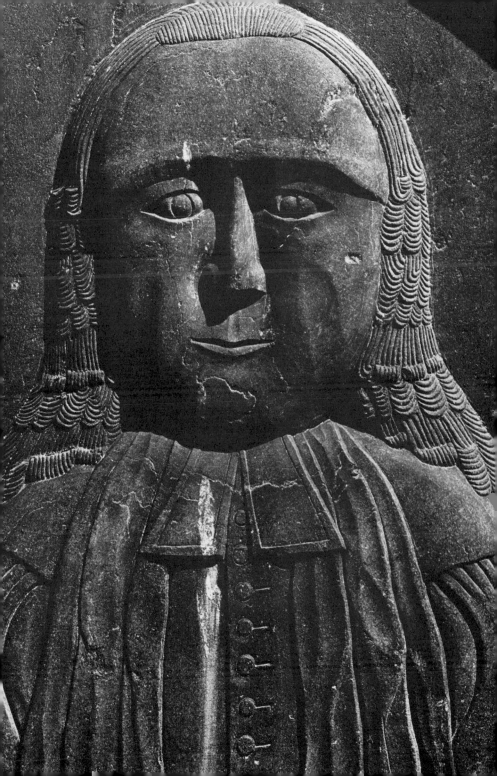

had spent on himself during his entire lifetime. Often his relatives were expected to commission a proper memorial in keeping with the deceased's social and financial position in the community and one that, incidentally, would serve to impress friends and neighbors.

According to probate records, contemporary journals, and the few stonecutters' ledgers still in existence, a none-too-subtle competitive spirit prevailed among certain townspeople, often so intense as to reach beyond the grave. This was shrewdly noted by enterprising stonecutters who jotted down such information in their day-books as a guide to the quality of stone and type of work desired. It was also used to good advantage when coming to terms on price. In some burying grounds the evidence is quite clear; one can actually trace the progress of this artifactual development and confirm it by checking dates on the stones. Nonetheless, the gravestone itself was probably one of the least expensive items charged off to the estate, usually costing less than the strong spirits passed around so liberally at Colonial funerals. It is interesting to note in passing that drinking became such a problem at wakes and burials that laws were eventually passed to prohibit the practice of serving rum punch and other intoxicants to the mourners.

Early New England gravestone-carvers seldom copied one another. Their favorite designs were judiciously taken from a variety of sources. Broadsides, with their rudely printed illustrations and commentaries on death were certainly an inspiration. So was *The New England Primer*, the first and most influential school-book published in the Colonies, which enjoyed a wide distribution throughout the eighteenth century. A few other illustrated books were available as were decorated objects imported from abroad which an artistic mind could draw upon. However, overall lack of abundant visual material to imitate often forced New England stone-carvers into more original and simplified graphic imagery than their European contemporaries.

Most carvers relied heavily on the natural living forms around them to embellish their stark symbols of death. William Young, of Worcester, whose masterful stones appear throughout central Massachusetts, specialized in carving indigenous plant forms. He carved so many thistles on gravestones for his Scotch-Irish compatriots that he ultimately became known as "The Thistle Carver of Tatnuck." John Stevens III, who lived in Newport, Rhode Island, ornamented the borders of his meticulously fashioned slate slabs with flowing vines resembling those that can still be found along that stretch of coastal shoreline. Connecticut stonecutters chiseled their own stylized botanical forms into the rich, red sandstone quarried in that area, as did carvers who worked the marble and slate of Vermont and New Hampshire. Even today one can

16. Detail of gravestone of Zechariah Long.
Charlestown, Massachusetts. 1688. Slate.

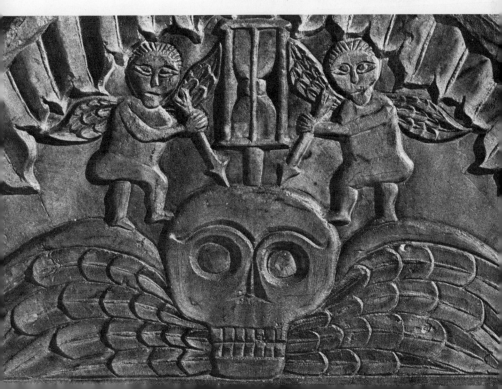

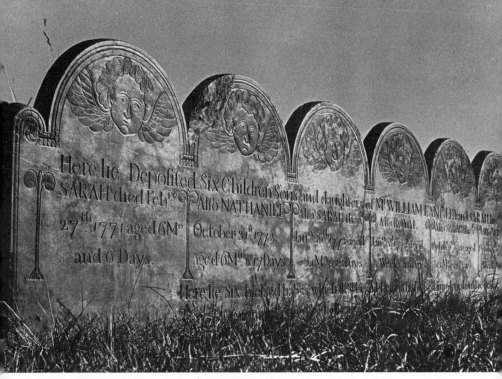

17. Gravestones of the six Langley children.
Newport, Rhode Island. 1771–1785. Slate.

look to the woods surrounding many country burying grounds and see a luxuriant backdrop of Concord and wild grapevines identical to the foliage and clustered grapes carved on the very stones there.

Colonial gravestones provide one of the richest sources of Puritan symbolism and design. Among the images most frequently encountered are death's-heads and angels, appearing in a surprising variety throughout the New England area. Flower motifs and geometric patterns (plate 5) were commonplace as border adornment, and the lush fruits of the Kingdom of Heaven turned up on many stones. Skeletons, imps of death (fig. 16), suns, coffins, hourglasses and scythes were also used to symbolize death. A scythe incorporated into a design meant the cutting off from earthly life.

An hourglass, pictured with its lower half filled with grains of sand, symbolized the same and was all the more emphatic when accompanied by the legend, "My Glass is Run." In coastal regions where inhabitants were accustomed to observing the sun rising and setting over the sea, tiny suns with human faces became popular. They were generally portrayed with eyes level to the horizon and represented the soul's ascent toward Heaven.

Sentiments expressed in epitaphs were usually simple and direct (fig. 17), although once the necessary vital statistics were provided, they often went on to describe in glowing terms the virtues of the recently departed. Many gave the cause of death, sometimes relating in sad detail the particular manner in which a person met his maker (fig. 18). A few even went so far as to add

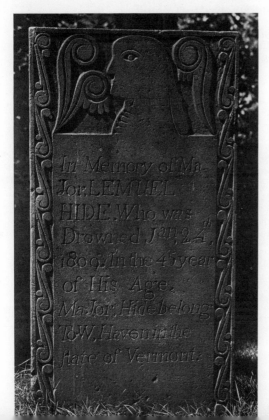

18. Gravestone of Major Lemuel Hide. Hadley, Massachusetts. 1800. Sandstone.

on the stone's pictorial part, graphic reconstructions of fatal acci-
dents. For example, a Pepperell, Massachusetts, stone (fig. 19)
shows in low-relief the startled figure of youthful Aaron Bowers
transfixed while in the throes of being crushed by falling timbers,
or, as bluntly stated by the inscription, "Instantly killed by a Stock
of boards." Another depicts a man killed by a fallen tree, his body
pinned beneath the heavy trunk and his ax lying nearby.

Images like these, plus an endless array of death's-heads,
grisly skulls, and articulated skeletons, populated every Colonial
graveyard. They were literary symbols made visual, the grim
quintessence of the popular injunction, "O Remember Death,"
which was carved onto so many gravestones. At a time when many
people could neither read nor write, the appearance of a grinning
skull and crossed bones on a stone in the meetinghouse burying
ground was enough to make its message clear.

Because it was fashionable for inscriptions to be accompanied
by verses both religious and sentimental, some gravestone-carvers
kept notebooks filled with snatches of poetry appropriate for all

19. Detail of gravestone of Aaron Bowers.
Pepperell, Massachusetts. 1791. Slate.

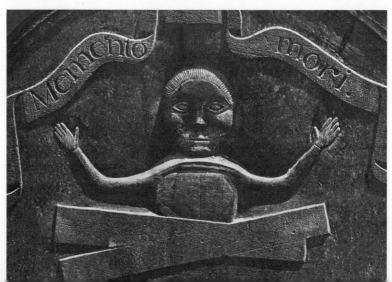

occasions. These were most often philosophical in content—pious admonitions to the living and powerful reminders that all men are mortal. Among the most common were variations of a verse that had originally appeared in English churchyards:

Death is a Debt
To Nature due
Which I have paid
And so must You.

New Englanders seemed to prefer a more refined version that, regardless of tempering, expressed the same idea:

Stranger, stop as You pass by
As You are now, so once was I
As I am now, so You will be
Prepare for Death and follow Me.

Supposedly humorous epitaphs sought out by collectors of such lore were not necessarily intended as such when they were first committed to stone. The quaint misspellings and curious phrasing that changed the original meanings of words were frequently the result of a barely literate stonecutter's or an occasional tippler's vain attempt to make sense from the scribbled copy handed to him by a bereft and perhaps not-too-well-educated family spokesman. There are numerous instances on seventeenth- and eighteenth-century gravestones where mistakes have been chiseled out and new lettering carved to make corrections. And there are others where a person's surname is spelled differently in two places on the same stone. Spelling was not standardized in those days and it is not surprising that many people wrote phonetically. It must also be remembered that at a time before schooling was mandatory, the stonecutter was as likely as any other apprentice or semiskilled laborer to be lacking

in formal education. One need only to stroll through an old New England burial ground, however, to appreciate that what most gravestone-carvers lacked in "book larnin" they easily made up for in artistic ability.

Whether from a sense of pride or for the more practical purpose of advertising, stonecutters sometimes signed the stones they made. Occasionally, they added a price carefully chiseled into the base of a beautifully carved gravestone. Prices seem to have conformed to the day-labor scale of that time, since the average gravestone required a week or so to make and cost somewhere in the

20. Detail of gravestone of Stephen Fisk. Wales, Massachusetts. 1785. Mica schist.

vicinity of $7.00. One early account book noted the price of three pounds, 17 shillings, and 6 pence charge for a stone in 1727, paid for by a man for his wife's grave. Later that very year the same person paid 2 pounds, 6 shillings, and 4 pence for a child's stone, which was probably somewhat smaller, indicating that price was determined by size and the amount of carving involved.

Today, even though many stonecutters remain anonymous, it is possible to recognize an entire body of work without ever knowing the carver's name. It is ironic, considering the importance of the artistic contribution to our nation's cultural heritage, that so little significance was accorded the work of gravestone-carvers during their own lifetimes. Epitaph hunting was a popular pastime during the nineteenth century but little attention was paid to the gravestone's aesthetic aspects. It is only during recent years that these carvings have begun to be appreciated and properly studied for their artistic merits.

Imaginative carving on gravestones flourished until shortly after the turn of the nineteenth century when designs became somewhat standardized and the art declined. These mostly anonymous stone-carvers have left a unique legacy of native symbolism and design in countless New England burying grounds, creating a naïve but often sophisticated, distinctly American folk art that can hold its own with the primitive art of any land (fig. 20).

FURTHER READING

FORBES, HARRIETTE MERRIFIELD. *Gravestones of Early New England and the Men Who Made Them, 1653–1800*. Boston: Houghton Mifflin, 1927. Reprints—New York: Da Capo Press, 1967; Princeton, N.J.: The Pyne Press, 1973.

LUDWIG, ALLAN I. *Graven Images, New England Stonecarving and Its Symbols, 1650–1815*. Middletown, Conn.: Wesleyan University Press, 1966.

PARKER, ANN, and NEAL, AVON. *Rubbings from Early American Stone Sculpture Found in the Burying Grounds of New England*. Limited Edition Portfolio, 1963.

TASHJIAN, DICKRAN and ANN. *Memorials for Children of Change. The Art of Early New England Stonecarving*. Middletown, Conn.: Wesleyan University Press, 1974.

WASSERMAN, EMILY. *Gravestone Designs, Rubbings and Photographs from Early New York and New Jersey*. New York: Dover Publications, 1972.

THE
WILDFOWL
DECOY

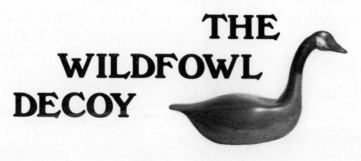

by

Adele Earnest

(Decoys from the collection of the author.
Photographs courtesy *Lithopinion* magazine.)

As folk art, the wildfowl decoy has the distinction of being uniquely American. Other people in other countries made and used primitive hunting lures but the decoy developed into a mature and highly diversified art form only in America. From Maine to Louisiana, hunters, fishermen, farmers, and sea captains carved and painted thousands of these extraordinary wooden birds: ducks, geese, shorebirds (fig. 21) gulls, herons, swans—sculptural Audubons.

The year A.D. 1000 marks the approximate time of the oldest known decoys found on this continent. They were made by Indians. Archaeologists from the Heye Foundation of the Museum of the American Indian, digging in Lovelock Cave, Nevada, in 1924, came across a set of decoys made of tule rushes and painted in earth colors. Nearly a thousand years ago some Indian hunter must have hidden his decoys for safe keeping until live birds would return the following spring.

The first hunters and trappers from Europe learned from the Indians. They needed food and wild game was abundant. During the eighteenth and nineteenth centuries the greatest bird migrations in the world passed over this land. But birds fly high.

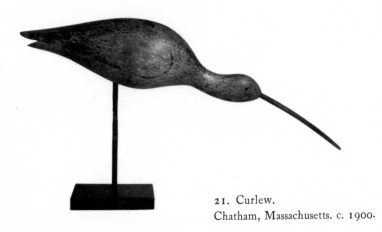

21. Curlew.
Chatham, Massachusetts. c. 1900.

The problem was to bring the bird down within range of gun or bow and arrow. The colonists saw how the Indian shaped bird images of reeds, mud, or root, and how he placed them intriguingly at the water's edge to lure wild birds out of the sky. They followed this working principle but their basic material was wood. There were plenty of trees in the forests. And most men were skilled in woodworking, carpentry, and boatbuilding. They had to be to live. And they had efficient metal tools that were unknown to the Indians. Also, early in the nineteenth century the Kentucky rifle was invented and later the 12-gauge shotgun. Both weapons proved more precise than those previously known. All these advantages, plus the easy availability of open bays and waterways that attracted birds, encouraged hunting and the making of decoys.

In general, decoys divide into two categories: floating tollers and "stick-ups." The floating decoys ride the surface of the water. They are weighted to balance and anchored so they can't drift away. Most numerous are the ducks. Sea duck decoys include canvasback, whistler, bluebill, redhead, bufflehead, scoter, coot, eider, ruddy, and old squaw. The pond decoys that the hunter used on inland water were mainly the black, mallard, pintail, widgeon, wood duck, and teal. The merganser—the crested aristocrat of the duck family—frequents both the sea and the marsh.

The stick-up decoys are mostly in the form of the delicate but sturdy shorebirds: plover, ruddy turnstone, yellowlegs, sandpiper, willet, knot, dowitcher, and curlew. To create the stick-up, a hole was drilled in the base of the carving and it was then mounted on a stick and propped on the beach, or the tidal flats where these "peeps" habitually congregate looking for edibles. A shorebird decoy must be more than sixty years old to be genuine folk art, not a reproduction. The Federal Migratory Bird Act in 1914 outlawed the practice of shorebird shooting.

The magnificent goose decoys may be floaters, or stick-ups, or

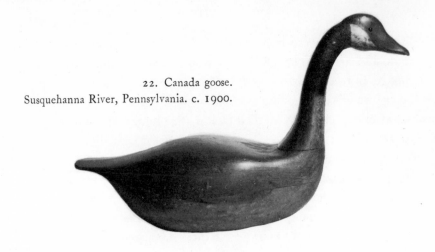

22. Canada goose.
Susquehanna River, Pennsylvania. c. 1900.

both. Sometimes the Canada goose model (fig. 22) was given three legs and placed in a cornfield after the harvest. The handsome black brant geese decoys are found along the Atlantic coast and have white bellies. The snow goose and the hutchins decoys are rare.

The prizes most eagerly sought are the one-of-a-kind "solitary persuaders," or "confidence" decoys such as the heron, egret, owl, crow, swan, and gull. Feather hunters as well as food hunters used them in the nineteenth century; the fancy plumage was sold to city milliners who decorated ladies hats with the wings, plumes, and exotic quills dyed in the current fashion.

An Audubon guide is helpful in identifying the decoy by species. But anatomical realism must not be expected. The fishermen and the farmers who created bird lures knew instinctively about impressionism and abstraction. Shapes were simplified. The prime purpose of decoy carving was to create the impression of a live bird, not to make a replica. Decoys may be full-bodied or in silhouette. The attitudes of the birds vary. Most are contented swimmers, or feeders, or sleepers. Head positions also vary. Wings may be curved, or incised in low-relief or merely painted.

The necessary tools of the carver were few; an ax, a pocket-

knife, a drawknife, and a gouge, plus sandpaper for finishing. A highly simplified but expressive decoy is the merganser by R. Williams (fig. 23). He simply took a fence post, split it down the middle, cut one half to the proper length, then pointed one end for a tail and the other end for a breast. The head is a "found" root, probably picked up on a beach on Long Island and inserted into the body. It's primitive but not crude. It says everything a decoy should say with no extraneous detail. And it is early. It can be dated around 1790.

The painting of the bird was as varied and distinctive as the carving. Simple washes were used with tonal treatment, as well as stippling and graining and formal patterns (plate 6). Some birds were not painted at all but simply creosoted or charred to preserve them against water and sun damage. Where paint was deemed necessary, a prime coat of white lead was usually applied first, then the soft, naturalistic colors. The eye might be a circle of paint, a gouge mark, an old button, or a fine glass eye from a taxidermist's shop. Feathers were suggested by painting techniques such as stippling, flecking, scoring, scratch coating, or graining with a comb.

Detailed featherwork was not necessary to attract birds but it gave pleasure to the painter. Birds, like people, react mainly to the key characteristics that identify an object. The Shourds' whistler decoy, for example, accented the distinctive white spots on the head and the dramatic black and white flashes that reflect the whitecaps of the sea. Harry Van Nuckson Shourds (1871–1920) of Tucker-

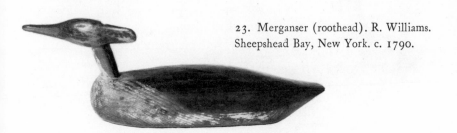

23. Merganser (roothead). R. Williams. Sheepshead Bay, New York. c. 1790.

ton, New Jersey, is considered the best and the most representative of the Jersey carvers. He was prolific. His son, Harry M., followed his father's patterns but made slightly larger "coys." And the grandson still carves in the family tradition.

It is fascinating to study how the style and construction of the decoy change in different locales and with the available native wood such as pine, basswood, cottonwood, cork, and balsa. Structural characteristics can reveal where a bird originated even if it is found far from home. In New Jersey most wildfowling takes place in protected bays and marshes. As a result the Shourds' decoys—typical of the area—are light in weight, small, often hollow with a smooth surface and rounded bottom.

In Maine where tides run high in the open sea and winds are brisk, the typical decoy is large and heavy with a flat bottom, wide beam, and a low head mortised into the body. This construction allows the handsome eider ducks, scoters and mergansers (plate 7) to ride without toppling over in rough water. Form follows function.

In Massachusetts Bay where the sea is calm, the decoys are lighter than the Maine birds. Massachusetts, where craftsmanship was always a tradition, produced much of our finest folk art, includ-

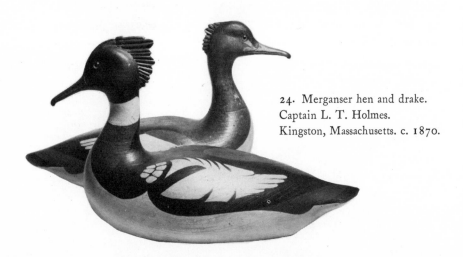

24. Merganser hen and drake.
Captain L. T. Holmes.
Kingston, Massachusetts. c. 1870.

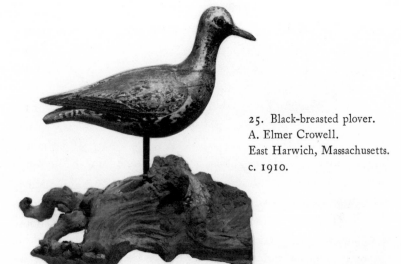

25. Black-breasted plover.
A. Elmer Crowell.
East Harwich, Massachusetts.
c. 1910.

ing decoys. The mergansers in figure 24 (hen and drake) by Captain L. T. Holmes (1824–1899) of Kingston are supreme. The sophisticated elegance of these decoys is especially remarkable since the man had no artistic or academic training. He was a ship's captain, and he knew his boats and his birds. He understood the rhythm and balance of natural phenomena. One pair by Holmes was shown at The Metropolitan Museum of Art in New York City in 1969, the first decoys ever acknowledged there as art. Holmes was one of the few carvers to brand his name on the bottom of his work. Most carvers did not sign their work; if a name or initial does appear, it usually indicates the owner rather than the carver. Such stamping helped prevent decoys from being pilfered if they washed ashore during a storm.

The most revered of all decoy carvers is Anthony Elmer Crowell (1852–1951) of East Harwich, Massachusetts. Crowell stamped his name on most of his ducks and geese. He made hundreds, for he served as guide and wholesale supplier for many

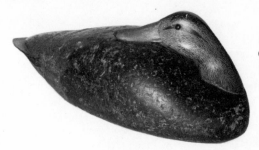

26. Sleeping black duck.
Charles (Shang) Wheeler.
Stratford, Connecticut.
c. 1925.

Boston sportsmen who might use as many as one hundred decoys in one rig for sea-duck hunting. Crowell also whittled songbirds and miniatures for the wives of his shooting companions. But the real prizes, as folk art, are the Crowell shorebird decoys (fig. 25), which were superbly sculpted and painted. These he rarely stamped but the natural poses and the subtle variations in brushstroke, tone, and density are readily identifiable.

In Connecticut the work of the "Big Three" of the Stratford School is avidly sought: Albert Laing (1811–1886); Benjamin Holmes (1843–1912); and Charles (Shang) Wheeler (1872–1949). The beautiful sleeping black duck in figure 26 is a Wheeler. Historically, Laing is the most important because he revolutionized the local carving practice. Before his day, Housatonic River "coys" had been shapeless blocks hewn with little care and called "old rockinghorses." Laing, a perfectionist, created a compact, organic, low-lying bird with a prominent breast to buffet the slush ice that clogs the river in March.

Long Island, across the Sound from Connecticut, has an impressive record of carvers in terms of known dates, places, and names. Its importance is due to the local salt marshes and inlets, which offer an ideal habitat for bird and man. Also the island lies in the center of the north-south Atlantic flyway; the main shooting occurred during the spring and fall migratory seasons. The native carvers most highly cherished include Obadiah Verity, Thomas Gelston, and William Bowman. All worked around the turn of

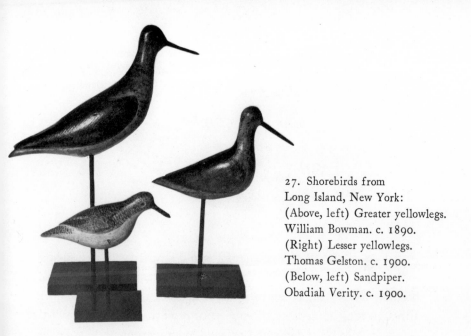

27. Shorebirds from
Long Island, New York:
(Above, left) Greater yellowlegs.
William Bowman. c. 1890.
(Right) Lesser yellowlegs.
Thomas Gelston. c. 1900.
(Below, left) Sandpiper.
Obadiah Verity. c. 1900.

the century. Illustrated in figure 27 is a group of their shorebird
stick-ups: a greater yellowlegs, a lesser yellowlegs, and a sandpiper.
The unique Long Island heron decoy shown in figure 28 is anony-
mous.

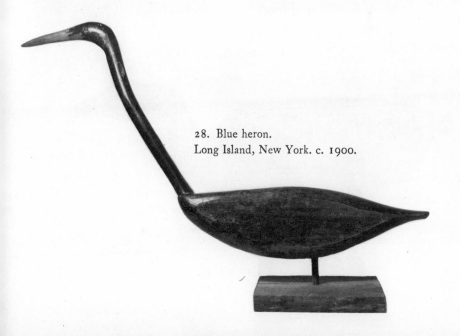

28. Blue heron.
Long Island, New York. c. 1900.

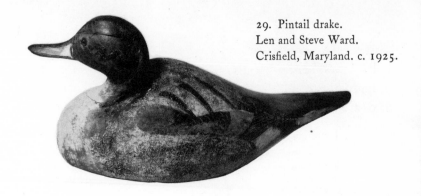

29. Pintail drake.
Len and Steve Ward.
Crisfield, Maryland. c. 1925.

Two of the most famous of the old-time carvers still living today are Lem and Steve Ward of Chrisfield, Maryland. These brothers have whittled and painted ever since they can remember although they earned their living, until recently, as barbers. Ward decoys include only ducks and geese. They experimented endlessly with the relationship of volume and contour in an effort to capture the grace of the wild duck (fig. 29) and to make a decoy that balanced, as if alive, on the choppy waters of Chesapeake Bay.

The "Cobb" goose (fig. 30) is a characteristic decoy of the renowned family that lived along the Virginia coast in the nineteenth century. The body of the goose was hewn from a ship's

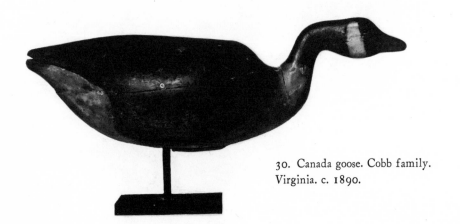

30. Canada goose. Cobb family. Virginia. c. 1890.

mast that had washed ashore. The head was shaped from a found holly root. This goose served a double purpose: as a stick-up propped in tidal flats and as a floater. Cobb geese, ducks, and shorebirds are true sculpture.

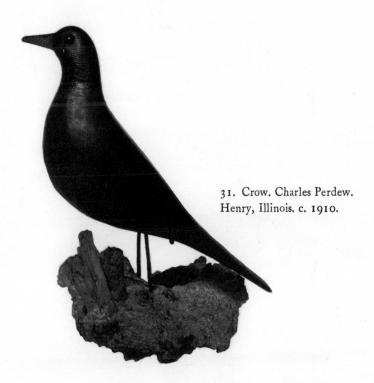

31. Crow. Charles Perdew. Henry, Illinois. c. 1910.

The Midwest has its own galaxy of decoy makers headed by Charles Perdew (1874–1963) of Henry, Illinois, and Robert A. Elliston (1849–1915) of Bureau, Illinois. The sleek crow (fig. 31) with its modern, streamlined look is by Perdew whose love was decoy carving, although he ran a bicycle shop, a repair shop for guns, and a livery stable to earn a living.

The fact that many carvers are known does not mean that birds by unknowns have less quality. The Shelburne Museum in Vermont exhibits the largest collection of decoys to be seen anywhere in a public museum. Most are anonymous. The superb collections at the Abby Aldrich Rockefeller Folk Art Collection in Williamsburg, Virginia, and at the Museum of American Folk Art in New York City are now being re-indexed because so much new information has surfaced in the last few years.

Manufactured decoys by known companies deserve an appre-

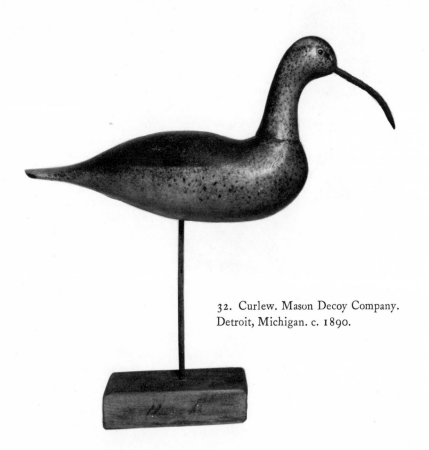

32. Curlew. Mason Decoy Company. Detroit, Michigan. c. 1890.

ciative look, and the best are highly prized. Although handcrafted, they are repetitive, not one of a kind, but the basic patterns were well designed. Toward the end of the nineteenth century the market gunners and sporting clubs demanded more decoys than individual hands could supply. Small factories appeared, mainly in the Middle West and upstate New York. The finishing was done by hand. Those employed might be only four or five members of one family. The most renowned was the Mason Decoy Company of Detroit, Michigan. Their catalogue announced that Mason was "the largest exclusive manufacturer of decoys in the world." It was probably right. Mason decoys of premier grade are treasures. A magnificent Mason curlew is illustrated in figure 32.

But the individual carver, the do-it-yourself man, continued to make his own birds of wood, even in areas where the factory product was purchasable. Today a good collection includes carvings that represent the various categories of ducks, geese, shorebirds and confidence decoys, all of which are examples from the work of our important carvers and outstanding regional work of sculptural quality. The great decoy is a rarity but it can still be found. It is more than an efficient tool, more than a replica of a bird. It is a unique, creative statement made by one man out of his need, with his observation of the natural world and his skill in expressing that vision.

FURTHER READING

EARNEST, ADELE. *The Art of the Decoy.* New York: Clarkson N. Potter, 1965.
MACKEY, WILLIAM J., JR. *American Bird Carvings.* New York: E. P. Dutton & Co., 1965.

PARMALEE, PAUL W., and LOOMIS, FORREST D. *Decoys and Decoy Carvers of Illinois*. De Kalb, Ill.: Northern Illinois University Press, 1969.

STARR, GEORGE ROSS, JR. *Decoys of the Atlantic Flyway*. New York: Winchester Press, 1974.

REDWARE
AND
STONEWARE
FOLK
POTTERY

by

William C. Ketchum, Jr.

A basic necessity, utilitarian pottery was among the first objects made in the American Colonies. The demand for cooking utensils, storage containers, and tableware compelled the settlers to seek a supplement to the limited amount of imported earthenware, and craftsmen in this field were among the most sought after immigrants. As early as 1635 there were three potters working in New England: Philip Drinker at Charlestown, Massachusetts, and William Vinson and John Pride, both of whom were established at Salem in the same colony. In New York the Dutchman, Dirck Claesen, was active by 1655, and by the end of the century most of the coastal settlements could boast of at least one resident pot maker.

These early craftsmen were accustomed to working in the large European potteries, which even in the seventeenth century operated as factories employing sophisticated methods and highly refined raw materials. Conditions were very different in the Colonies. Even the fundamental necessities, such as bricks for the kiln, were often in short supply, and tools and glazing materials were an unheard-of luxury. But the potters were adaptable men, and they adjusted to the environment. Instead of the great brick kilns of Europe they built tiny barrel-shaped ovens, appropriately termed *ground hog* kilns. And, instead of the fine porcelain and white earthenware intended to grace the tables of aristocracy they turned out simple "dirt dishes" for use in the log cabins of a new country.

REDWARE

The commonest raw material utilized by these early artisans, and one that continued to be employed in isolated areas as late as 1930, was common brick clay that fired to a red color, hence the term *redware*. This earth was available everywhere, and it could be baked to maturity at 1700 degrees Fahrenheit, a temperature

that could be achieved in the primitive ovens available. With this clay, lead for glazing, and a few mineral colors, the potters achieved a high art. Though few pieces from the earliest period are still in existence, it is clear that from the first, even the most mundane objects were thrown with great care and taste. Graceful ovoid shapes prevailed, particularly in the jugs and storage crocks that were always the staple output of any kiln (plate 8). At first, there was neither time nor material for decoration, and most seventeenth-century ware was embellished with nothing more than a few incised lines about the body and a clear lead glaze through which the red or orange body color may be seen. This glaze was always present since without it the porous clay body would not hold water; but it might often appear, particularly in early pieces, only on the interior of the vessel, leaving the outside surface rough and bare.

With the passage of time and the accumulation of some modest wealth, the early settlers began to demand more attractive wares. Since the mother country was eager to supply this need with exports, local craftsmen found it essential to offer a competitive product. Cobalt, manganese, iron oxide, copper salts, and other coloring agents were mixed with the lead glaze or applied beneath it to produce multihued objects of great beauty. Particularly in New England and Pennsylvania, eighteenth- and nineteenth-century folk potters produced a ceramic art to rival that of Europe and Asia. In New England, free-flowing glazes were employed to achieve abstract patterns (plate 9) whose seeming casualness concealed an instinctive taste and skill. In Pennsylvania and North Carolina potters, primarily Germanic in origin, created more structured designs. They employed sgraffito, the technique of cutting through a layer of slip to the base clay to produce a color contrast in the elaborate pictorial designs on plates (fig. 33) and other objects. Scenes of historic significance or local importance would be laid out on these pieces, often accompanied by appropriate verses, as well as

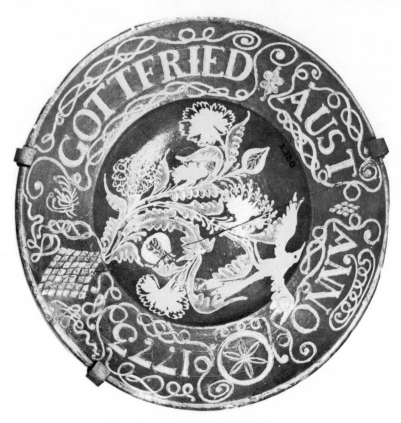

33. Redware plate with slip and sgraffito decoration.
Gottfried Aust. Salem, North Carolina. 1773.

dates, and names of donors and recipients. Collectors were attracted
to the folk pottery of the Pennsylvania Germans at an early date,
and much of it is currently in museum collections.

Because redware clay was extremely adaptable both to throw-
ing and molding, it was utilized in a great variety of objects. Al-
though jugs and storage crocks predominate, nearly everything that
could be made in wood or metal has been attempted in this medium.
Tableware, including plates, pitchers, bowls, and cups, were rela-

tively common as were whiskey kegs, flasks, and mugs. Useful articles such as inkwells, soap dishes, strainers, lamps, skillets, candlesticks, bedpans, hot-water bottles, churns, shaving mugs, and washbasins may be found in this red earth. For some objects, redware did not prove equal to the task, and the scarcity of things like churns (soon beaten to pieces by the housewife's constant labor) reflects this sad fact.

Few country craftsmen seem to have had molds, for molded objects in redware are far less common than those thrown on a wheel or cut out by hand. There is no doubt, however, that the technique was employed in this country at an early date (fig. 34). Gottfried Aust and Rudolf Christ, resident potters at the Moravian settlements of Salem and Bethabara in North Carolina, made a wide variety of molded objects in the late eighteenth and early nineteenth centuries. Molds employed by these men in the manufacture of various ceramic objects have been preserved. They include molds for bottles in the shapes of fish, turtles, and squirrels, as well as a

34. Redware Turk's cap cake mold. Perine Pottery, Baltimore, Maryland. c. 1850. (*Maryland Historical Society*)

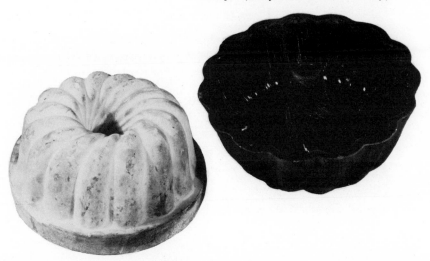

variety of press molds for plates. At a much later date, the well-known Bell Pottery at Waynesboro, Pennsylvania, made several molded forms including a cann or drinking mug clearly modeled after an English silver form.

This Bell cann, although unusual, is not a unique expression of the effect on the American ceramics industry of European taste and style. It need hardly be said that the earliest potters worked, as far as limitations imposed by materials and tools allowed, in the manner of their fathers. Moreover, as foreign ceramic designs changed and these changes were reflected in wares imported into this country, domestic craftsmen adopted what they liked or felt was salable. For example, English Staffordshire china, particularly dogs and other animal figures, was widely copied here; and redware dogs are among the most common examples of American molded pottery. The potter also borrowed from other disciplines than his own; silver designs were reproduced in ceramic form, and even architectural motifs were adopted. The swag-and-tassel design basic to wood carving of the Adam period is found incised or applied in glaze on the surface of early nineteenth-century American pottery.

It should not, however, be assumed that the native artisan slavishly copied from his European competitors. He took what he needed and modified it to suit his taste and that of his customers, and the ware he created was uniquely expressive of the new land.

STONEWARE

Stoneware clay, a fine white soil found primarily in Ohio and the Atlantic coastal states, was the other medium in which the folk potter worked. Stoneware clay fires at a much higher temperature (around 2300° F.) than redware, and the ceramic body produced is impervious to water, as well as steel hard. These obvious ad-

vantages attracted early potters to it, and European artisans had employed white clay for many centuries prior to the discovery of America. The problems inherent in the making of stoneware delayed its utilization on this continent. There is no present evidence that kilns capable of withstanding the great heat necessary to mature the ware existed here before the eighteenth century. Recent excavation has confirmed the existence of such an oven at Yorktown, Virginia, where William Rogers made stoneware circa 1720–1745. There is also evidence to indicate that both the Crolius and Remmey potteries that were active in New York City prior to 1735 manufactured the same product.

Like redware, early stoneware was plain and unadorned. Shards discovered at Yorktown indicate the wares made there to have been of ovoid or bulbous shape and to have been decorated only with a few incised lines around neck and base. This classic form persisted well into the nineteenth century with the pieces gradually becoming less curvilinear, culminating in the straight-sided style (fig. 35) common after 1850.

Glazing also changed with time. Stoneware does not, of course, require a sealing glaze, being impervious to water. For the sake of appearance it has, however, traditionally been coated with a glasslike film produced by the vaporization of salt thrown into the kiln when the fire is at its height. Early pieces such as those from Yorktown, New York, and Boston also reflect employment of iron oxide to produce a brown decorative glaze on both the exterior and interior of the vessel. From an early date, cobalt and manganese, the only two minerals that can withstand the temperature at which stoneware is fired, also were utilized to decorate the exterior of certain pieces. Early adornment was extremely simple, consisting primarily of blue or brown dashes and swirls or, more often, of a color filler intended to give highlight to incised decorative devices such as flowers, birds, and figures, which were frequently

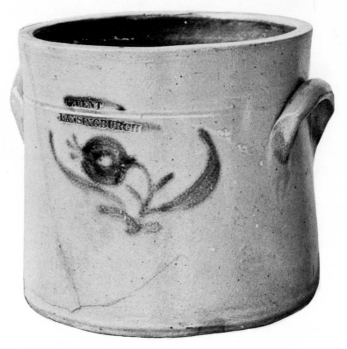

35. Salt-glazed stoneware crock with blue floral decoration
(tulip in the wind). George Lent. Lansingburgh, New York. 1825–1831.
Photograph courtesy Mrs. Warren J. Broderick. (*Lansingburgh Historical
Society*)

found on stoneware from 1755 to 1825 (plate 10 and fig. 36).
During the same period, wood or metal stamps were also employed
to impress a design such as an eagle or swag on the wet surface of
the unfired pots.

After the general disappearance of incised and impressed
decoration, potters used cobalt slip, applied with a brush or slip cup,
to make crude abstract or figural decorations on their wares. Little
of this work is of artistic merit, and it was not until the advent of
the straight-sided pot around 1850 that the use of cobalt realized
its full potential. The change in form coincided with the introduc-

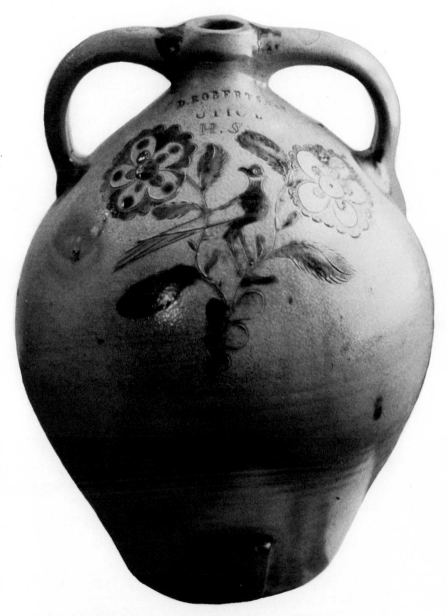

36. Salt-glazed stoneware water cooler with incised and cobalt decoration. David Roberts. Utica, New York. 1827–1828.

tion of Spencerian penmanship, a graceful and flowing style of writing that was introduced in American schools prior to the Civil War. Students trained in this discipline were capable of executing remarkable floral and geometric compositions that admirably suited the extended surface of the stoneware being made. From 1850 to 1900 potteries, particularly in the northeastern states, created a vast amount of blue-decorated pottery, some of it in the finest tradition of American folk art (plate 11). Birds, ships, flowers, animals, and at times, whole communities ranged across the faces of otherwise prosaic jugs, crocks, and churns.

37. Salt-glazed stoneware whiskey keg with cobalt decoration. Clarkson Crolius, Sr. New York, New York. 1800–1814.

Stoneware, because of the difficulty of working and firing it, never appeared in the variety of types common to redware. Crocks and jugs are the most common, followed by churns, pitchers, and water coolers. Mugs, batter jugs, inkwells, spittoons, flasks, bottles, and jars are also frequently encountered. All other forms must be considered rare.

As with redware, stoneware was affected by the forms imported from Europe. Early examples are clearly related to contemporary German and English pottery. At a later date, the ubiquitous Staffordshire dog appeared in stoneware, and a few other mold-made pieces show European influence. The elaborate blue decoration of the Victorian era was, however, an indigenous development and one that owed no debt to foreign potters. If American stoneware is judged on this alone, it will compare most favorably with ceramics produced in other areas of the world. It should, of course, be borne in mind that our folk pottery was always primarily utilitarian (fig. 37). It was intended to be used and not just looked at, and in those pieces most worthy of preservation the blend of function and decoration is imperceptible but perfect.

FURTHER READING

BARBER, EDWIN ATLEE. *Marks of American Potters.* Southampton, N.Y.: Cracker Barrel Press, 1969.

————. *Tulip Ware of the Pennsylvania-German Potters.* New York: Dover Publications, 1970.

BARRET, RICHARD C. *Bennington Pottery & Porcelain.* New York: Bonanza Books, 1968.

BIVENS, JOHN, JR. *The Moravian Potters in North Carolina.* Chapel Hill: University of North Carolina Press, 1972.

GUILAND, HAROLD F. *Early American Folk Pottery.* Philadelphia: Chilton Book Co., 1971.

KETCHUM, WILLIAM C., JR. *Early Potters and Potteries of New York State.* New York: Funk & Wagnalls, 1970.

———. *The Pottery & Porcelain Collector's Handbook.* New York: Funk & Wagnalls, 1971.

OSGOOD, CORNELIUS. *The Jug and Related Stoneware of Bennington.* Rutland, Vermont: Charles E. Tuttle Co., 1971.

QUIMBY, IAN. *Ceramics in America.* Charlottesville: University Press of Virginia (Winterthur Conference Report), 1973.

RAMSEY, JOHN. *Early American Pottery and China.* Boston: Hale, Cushman & Flint, 1939.

SPARGO, JOHN. *The Potters and Potteries of Bennington.* New York: Dover Publications, 1972.

SCHWARTZ, MARVIN. *Collectors Guide to American Ceramics.* New York: Doubleday, 1969.

WATKINS, LURA WOODSIDE. *Early New England Potters and Their Wares.* Cambridge: Harvard University Press, 1950.

WEBSTER, DONALD BLAKE. *Decorated Stoneware of North America.* Rutland, Vermont: Charles E. Tuttle Co., 1971.

FOLK
ART
OF
SPANISH
NEW
MEXICO

by

Robert J. Stroessner

EARLY HISTORY

Francisco Vasques de Coronado's luckless expedition to the New World in 1540 led the Spanish into the vast Southwest, and even through central Kansas. Settlements were established shortly afterward in areas that were to become the states of California, Texas, Arizona, and New Mexico. Each eventually developed a distinctive regional style that blended European and local native Indian traditions.

Actively colonizing the Rio Grande valley of New Mexico by 1598, the Spanish settlers constructed villages and mission churches in or near native Indian pueblos. Little remains from this first colonial period. It ended abruptly with the Pueblo Revolts of 1680 when the Spanish were driven as far south as El Paso. The area was reconquered in 1692 by a Mexican military expedition under Diego de Vargas but most of the original colonial buildings had been destroyed or burned. An exception was the Governor's Palace in Santa Fe, which the Indians had used as a fortress. After the battle of Sante Fe and a few minor skirmishes, the foundations were laid for the peaceful coexistence of Spanish and Indians that has continued to this day.

With survival and protection in mind, Spanish villages were rebuilt as enclosed, fortified compounds around a central plaza and were located next to the Indian pueblos, since both populations had to share the rich valley floor and the water from the Rio Grande. A unique cultural blend gradually developed through the reciprocal influence of European and native traditions. The Spanish brought the Catholic religion, a new language and social structure, metal tools, and domestic animals. Under the Spanish influence, the Indian modified his traditional mudded-stone architecture to accommodate adobe bricks and adapted ancient textile techniques to

the wool yarn that became available when the settlers introduced sheep. The Indian also shared with the Spanish settlers his knowledge of native agricultural products and methods of adaptation to the local climate and land.

ARCHITECTURE

Colonial architecture incorporated the ageless traditions of adobe construction (fig. 38). Walls were heavy and low with few windows or doors. Roofs were made by crossing split or peeled branches (*latias*) over massive pine beams (*vigas*) and topping them with brush, straw, and mud plaster. Roofs were pitched for drainage and were often staggered from room to room, allowing for clerestory windows to bring light to dark interiors. These small rooms were sometimes connected by roofed breezeways (*zaguanes*) that provided ventilation and working space in summer and storage room in winter. Floors were of pounded earth, often hardened with a mixture of water and animal blood.

The stark simplicity of adobe walls was embellished with decorative details on structural elements such as porches, doors, and

38. Apse and morada. Las Trampas Mission, New Mexico. Dating after 1775. Photograph courtesy Paul Harbaugh.

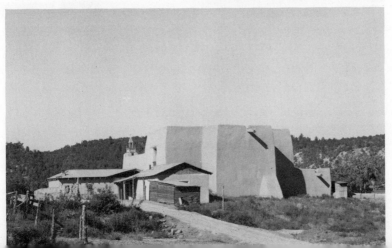

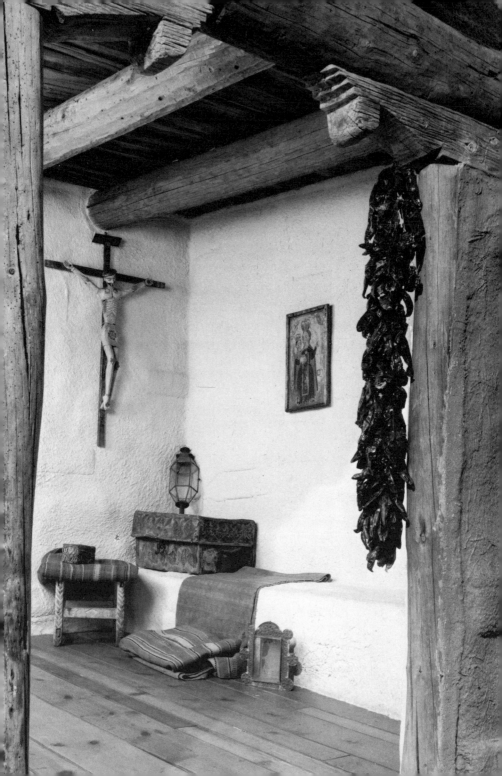

windows. Porches, which offered shade and protected the adobe walls from rain and snow, were sometimes a roofed overhang of house beams. More often they had their own beams. One end of the *viga* was embedded in the adobe wall with the other end resting on a long outside crossbeam supported by posts and corbels. The corbels, which were often carved with steps and scrolls, helped distribute the weight of the roof along the outside crossbeam. They were also frequently used inside buildings (fig. 39) to aid ceiling beams in supporting the heavy roof, whose weight increased with each layer of adobe plaster that was added when leaks or cracks were repaired. In contrast to Spanish colonists elsewhere, those of New Mexico used neither roof nor floor tiles. Tiles were available from the Pueblo Indians who supplied all the local ceramic needs, but adobe roofs were used exclusively until the 1860s, when tin or shingle shed roofs were added to many of the old buildings.

New Mexico was poor in native metals. Copper cooking pots and silver serving pieces, for those who could afford them, were nearly all carried north from Mexico. Even iron was a rare material, which was used and reused for vital tools. The colony could never afford the luxury of elaborate iron grilles and balconies typical of other Spanish colonies. Doors and shutters were often designed without iron hinges. Instead, they were made of heavy slabs of wood (fig. 40) that swung from round poles extending into the sills. Doorways were small with high sills and low lintels, so that one had to step up and bend over to enter a room. Although inconvenient, this arrangement helped to keep out water and dirt and to hold in warmth. Windows, too, were small and often placed

39. Adobe interior showing corbels at doorway
and the built-in ledge *tarima* beneath
the beamed ceiling of *vigas* and *latias*.
Reconstruction in The Denver Art Museum
of Duran Chapel interior. Talpa, New Mexico.
c. 1840. (*The Denver Art Museum*)

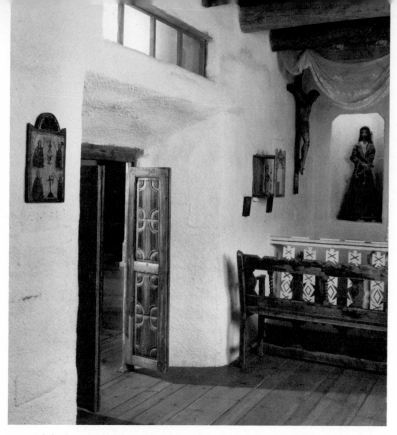

40. Adobe interior with typical colonial puncheon-style doors
and clerestory windows. Reconstruction in The Denver Art Museum of Duran
Chapel interior. Talpa, New Mexico. c. 1840. (*The Denver Art Museum*)

high in the wall for protection. Sometimes covered with hides or
small panes of native selenite held in place by wood stringers,
windows were often shuttered for additional protection, or, like
porches, shielded by wooden grilles of flat planks or hand-carved
spindles.

INTERIORS

Interiors were simply furnished. Nearly every room had a
corner fireplace raised on an adobe ledge. This ledge (*tarima*)

often extended around the room, adding support to the wall and offering a built-in bench (fig. 39) for seating, sleeping, or storage. Interior walls were whitewashed and sometimes decoratively painted with colored or micaceous clays mixed in the plaster. Wall cupboards (*alacenas*) or niches, which were often cut out of the walls, were usually enclosed with a door or grille similar to those used on windows.

Furniture was often limited to chests and cupboards (*trasteros*), which were nearly always made of local pine (fig. 41).

41. Adobe interior with cupboard (*trastero*) and rawhide trunk (*petaca*). Reconstruction in The Denver Art Museum of Duran Chapel interior. Talpa, New Mexico. c. 1840. (*The Denver Art Museum*)

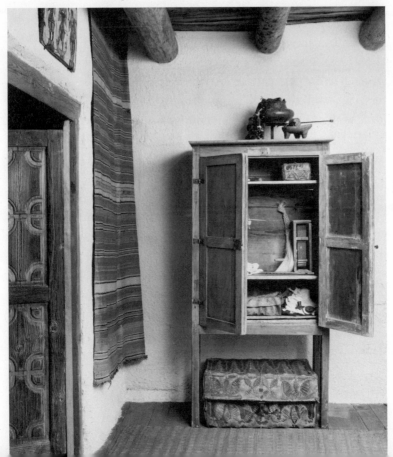

Until trade chests from Mexico and China brought in the fashion for brightly painted furniture, the roughly cut pine was left unfinished. Ranging in size from tiny trinket boxes to enormous granary coffers, chests were often carved with shallow relief designs of lions, flowers, and scrolls in the eighteenth century. Later examples feature simple geometric designs of incised lines.

There were few bedsteads, sofas, or chairs; bedrolls of homespun stuffed with straw or piles of hide blankets served for both sleeping and sitting. Locally crafted chairs and benches were simple and sturdy, with railed or splatted backs and heavy aprons and stretchers. These were usually chiseled with stepped or scalloped edges and incised with traditional geometric designs. Arms were square and frequently carved like miniature corbels. Joints were mortised and tenoned or dovetailed without nails.

Church interiors were furnished with equal simplicity. Early altars were adobe ledges projecting from the apse wall, on which an altar screen was painted. A wooden pulpit, baptismal font, confessional, and altar rail completed the furnishings. Benches and pews were rarely used until late in the nineteenth century. Families brought blankets or chairs with them or simply stood throughout the service.

In 1761, a dramatic change in church interiors was signaled by the remodeling of the Governor's Palace and the construction of the new Military Chapel (*Castrense*) with its imported stone altar screen carved by Mexican artists. Soon, wooden copies of this stone altar screen appeared in many of the old churches. Carved and painted wood frames were hung above the altar to exhibit imported statues or paintings belonging to the parish. But since New Mexico's isolation from New Spain prevented much trade beyond the bare necessities of life, local artists soon began making statues and panels to fill the new altar screens.

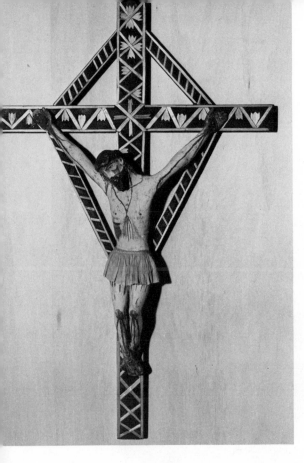

42. Crucifix. Artist unknown. c. 1820. Straw-decorated cross with gessoed and painted corpus. 28″ × 19″. (*The Denver Art Museum*)

DECORATIVE TECHNIQUES

Both household and religious objects were often decorated with straw. This craft had been brought to Spain by the Moors and was used from early colonial times in New Mexico. Such items as small boxes, panels, picture frames, hanging shelves, shrines, book stands, and devotional crosses (fig. 42) were coated with a thick paste of rosin mixed with soot, which dried to a shiny black that simulated lacquer. After pressing split stems of straw or pieces of corn husks into the wet paste, the craftsman cut it into borders,

geometric flowers, or checkerboard patterns. The golden color of the straw, which glitters in candlelight, earned this craft the name of "poor man's gilding."

The opening of the Santa Fe Trail in the nineteenth century brought an influx of Eastern traders, miners, soldiers—and tin cans. Because of the scarcity of metals in New Mexico, the cans were recycled and used as decorative household items (fig. 43). Picture frames, small shrines for *santos*, trinket boxes, candlesticks, lanterns,

43. New Mexican tinwork. Artist unknown. c. 1880. Tin.
Chandelier: W. 26". Niche: H. 12". Candlestick: H. 8". Frame: H. 7".
(*The Denver Art Museum*)

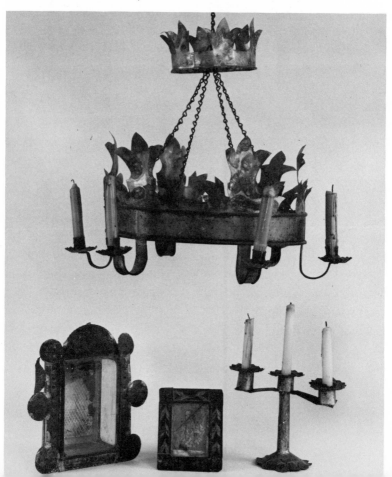

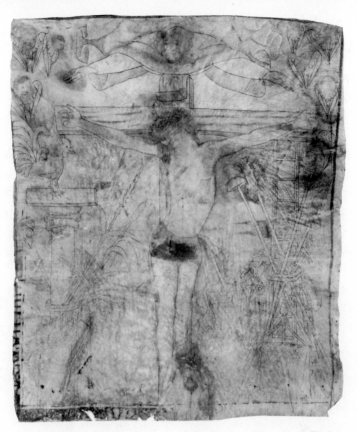

44. Crucifixion with Instruments of the Passion. "Franciscan F" Santero. Early eighteenth century. Painted buffalo hide. 55½″ × 48″. (*The Denver Art Museum*)

and the many-armed chandelier (*araña*) that had formerly been made from scraps of iron now appeared in elaborate tin versions. Strips of tin were beaten over molds in the repoussé technique or were finely tooled and stamped with border designs before assembling and soldering. Scraps of glass, imported wallpaper, and brightly colored prints lined the frames and shrines. The shapes were flamboyant, and the bright colors and polished metal were highly esteemed.

Animal hides were another important material in old New Mexico. As a household material, leather was used to curtain win-

dows. Rawhide strips were braided into slings for storage off the floor and to hang wooden shelves where clocks, *santos* or other personal effects were displayed. Rawhide was also used to make traveling trunks and storage boxes (*petacas*) that were lightweight and strong. Tanned leather was used to make shoes, clothing, bags, and saddle trappings. Paintings on Indian-tanned buffalo hides (fig. 44) are believed to have served early missionaries as portable teaching devices used to instruct the natives in the Christian religion. Piles of buffalo and sheep hides with their fur intact were used as bedding and mattresses, and for seating.

SANTOS

Santos, the carved or painted religious images, are of two types: statues (*bultos*) carved from cottonwood root (fig. 45) and paint-

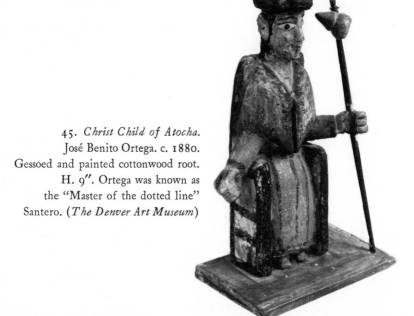

45. *Christ Child of Atocha.* José Benito Ortega. c. 1880. Gessoed and painted cottonwood root. H. 9″. Ortega was known as the "Master of the dotted line" Santero. (*The Denver Art Museum*)

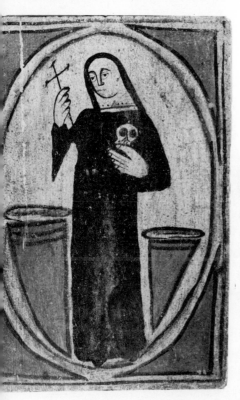

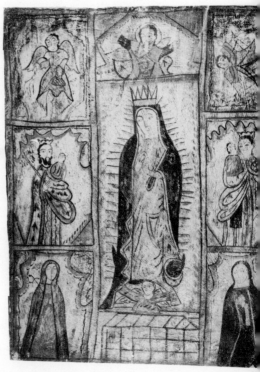

46. *Santa Rita of Cascia.* Molleno. c. 1840. Gesso on pine panel. 11″ × 7½″. Molleno, known as the "Chili Santero." (*The Denver Art Museum*)

47. *The Virgin of Guadalupe.* Pedro Antonio Fresquís. c. 1820. Gesso on pine panel. 23″ × 17½″. Miniature altar screen or *reredos.* (*The Denver Art Museum*)

ings (*retablos*) on hand-adzed pine panels (fig. 46). *Bultos* and *retablos* were frequently combined in a single large composition called a *reredos* (fig. 47). The *santero* prepared the raw wood for painting by covering it with a layer of *yeso* (gesso) made of animal glues mixed with ground gypsum. After the surface had been painted with water-soluble pigments, it was often glazed with egg white, rosin, or wax which, darkening with age, give the characteristic "golden glow" to many of the old *santos.*

Many of the earliest santeros appear to have been Franciscan

missionaries with some knowledge of art techniques and iconography. Such artists as Fray Andres García and other anonymous santeros who carved and painted images for mission churches during the last part of the eighteenth century found their inspiration in the late Mexican baroque style. This style is seen in the copper engravings of their missals or in objects imported from Mexico.

The oldest and best-preserved altar screen known today is in Mission San José at Laguna Pueblo. The author of this *reredos* is anonymous, known only by the nickname, "The Laguna Santero." He was a major influence on the second generation of New Mexican santeros, and may have been Fray José Benito Pereyro, the missionary who served both the Laguna and Acoma missions between 1798 and 1803. Almost identical altar screens were constructed at these two missions during the time of his service.

Among the important second generation santeros, Molleno, the "Chili Painter" as he is sometimes called, may have been trained under the Laguna Santero. Throughout his long career (1804–1845), Molleno made use of space fillers such as columns (fig. 46) and acanthus leaves derived from engravings. In his middle and late periods, these designs became increasingly abstract geometric forms that, in truth, often resemble large chilies. Molleno also appears to be the author of several existing gesso relief panels. On these rare panels the outline of the subject is built up with layers of sculptured gesso (fig. 48), thus combining the traditions of *bultos* and *retablos*.

Pedro Antonio Fresquís, credited with the original wall painting above the High Altar at Las Trampas, as well as several large wooden altar screens at Las Truchas, Chamita, and Nambe, has recently been identified as the hitherto anonymous "Calligraphic Santero." His distinctive style was derived from the technique for true fresco mural painting, which requires incised outlines and rapid execution before the plaster dries. The subjects of his *retablos* were

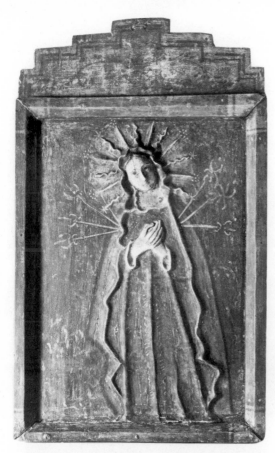

48. *Virgin of the Seven Sorrows.*
Attributed to Molleno. c. 1800.
Gesso relief on
pine panel. 22½″ × 14″.
(*The Denver Art Museum*)

incised in wet gesso and painted with a florid brushwork and
nervous line, which suggests he had executed many of the earlier
type of altar screen that was painted directly on a church wall.

A number of large single panels survive, which represent min-
iature altar screens in this style. These miniatures may have been
used as models for large-scale works now vanished. Fresquís also
made several gesso relief panels and was active until his death near
Las Truchas in 1831.

Most santeros remain anonymous because very few of their
works were signed or dated. An exception was José Aragón, who,
between 1820 and 1835, inscribed many of his panels with prayers,

dedications, dates, and signatures. He came from Spain about 1810 and established a studio at Chamisal where he seems to have trained several assistants who continued to work after his departure from the colony about 1835.

With the third generation of artists (1830–1860), the santero's art entered its golden age. Raphael Aragón of Cordova and his anonymous helper, who may have been his son Miguel, created many of the altar screens as Chimayó, Cordova, Santa Cruz and Taos. Both his *retablos* (fig. 49) and *bultos* have a gentle appeal to modern eyes, which evaluate his works at the apex of the tradition. His most famous contemporary was the anonymous "Santo Niño Santero," named for his many figures of the child Christ.

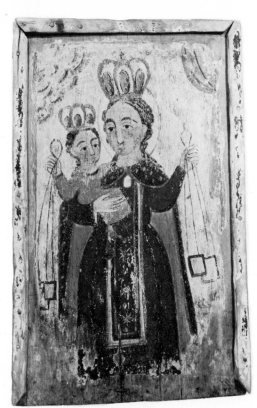

49. *Our Lady of Mount Carmel.*
Rafael Aragón. c. 1840.
Gesso on pine panel. 21″ × 13″.
(*The Denver Art Museum*)

By the 1860s many of the old churches were in need of repairs. Tin roofs and spires and wooden floors were added to the buildings, and many of the old altar screens were whitewashed or overpainted in oils. Several anonymous santeros continued the tradition in isolated northern villages until milled lumber and commercial paints replaced the old materials. The Mexican artist José de García Gonzales traveled through New Mexico in the 1860s and painted over several of the traditional altar screens with bright oil paints. Native sons such as José Benito Ortega of Mora (fig. 45) and Juan Ramon Velásquez of Canajilon continued New Mexico's folk tradition into the first years of this century.

THE PENITENTE BROTHERHOOD

New Mexico's long isolation as a Spanish colony fostered an atmosphere of stubborn self-determination. In the absence of government supervision, social structure was largely determined by the Franciscan Order. The Penitente Brotherhood (*Los Hermanos Penitente*), a secular order of Saint Francis, was established at the time of the first settlement in 1598 and assumed great importance when Mexico's War of Independence led to the recall of many Franciscan priests. Community leadership was placed in the hands of village elders, already organized under a deacon (*hermano mayor*) of the Penitente Brotherhood. The brotherhood gradually became synonymous with social order, and members functioned as leaders in all public affairs. Special altars and chapels were constructed in most of the old parish churches while meeting houses (*moradas*) were built in every village. The demand for Penitente furnishings gradually became the main force in santero art in the last half of the nineteenth century.

Life-size Penitente statues frequently have articulated arms and legs, which allowed them to be placed in the positions of the

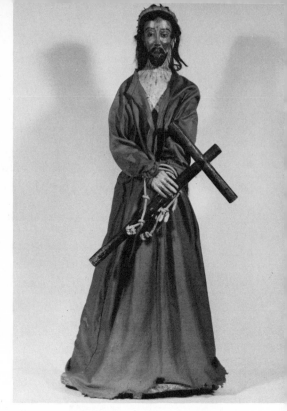

50. *Penitente Standing Christ.*
Artist unknown. c. 1825.
Gessoed and painted
cottonwood root. H. 52″.
(*The Denver Art Museum*)

Stations of the Cross. Like large puppets, these figures (fig. 50) could be dressed in robes and rope belts by which they were tied to a column, cross, or processional litter. Figures representing Christ at the column, Christ crucified (plate 12), and Christ in the sepulcher, as well as figures of penitents and death (plate 13) were carried in processions during Holy Week and enshrined in the *moradas* during the rest of the year. Penitente figures are more stark and strident in expression than other *santos*, illustrating a preoccupation with the wounds and blood of the Passion.

TEXTILES

Like many other necessities textiles had to be locally produced by the New Mexican colonists. Because of their scarcity, used fabrics

PLATE 1. Central portion of Van Bergen overmantel. Artist unknown. 1733-1735. Oil on wood. W. of entire painting: 7½'. The earliest-known American genre painting, this piece is also important as a unique historical document. (*New York State Historical Association*)

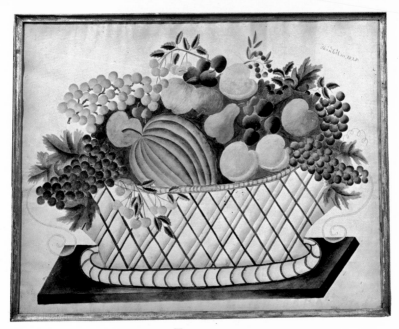

PLATE 2. Watercolor theorem on paper. Artist unknown.
Inscribed in upper right corner "Painted in 1825."
17½" x 22¼". This is a fine example of the then popular
technique of painting with stencils. *(Private collection)*

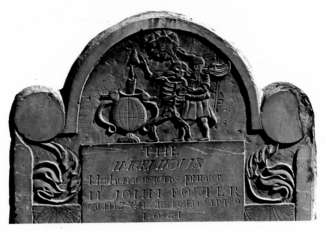

PLATE 3. Detail of John Foster gravestone.
Dorchester, Massachusetts. 1681. Slate.

PLATE 4. Detail of Captain and Mrs. Blower gravestone.
Cambridge, Massachusetts. 1709. Slate.

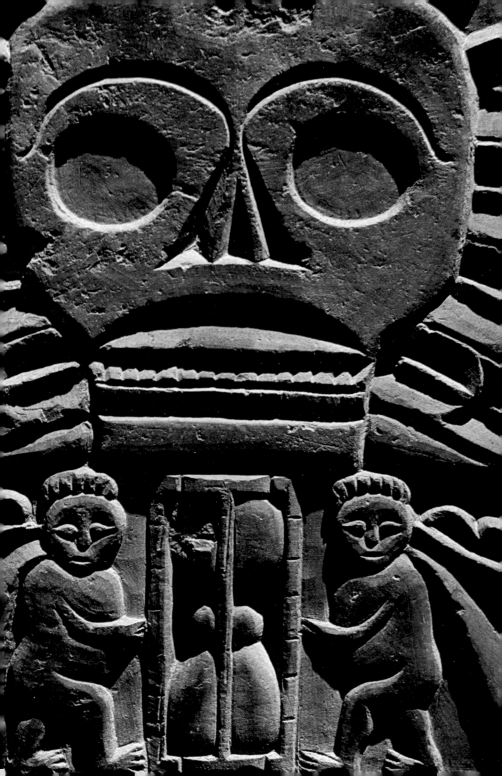

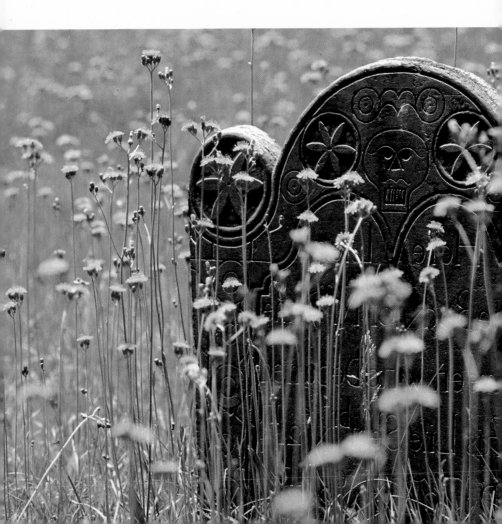

PLATE 6. Widgeon decoy.
John Dawson. New Jersey. c. 1900.
(George F. Wick)

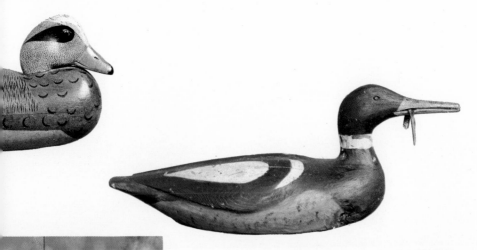

PLATE 7. Merganser decoy with minnow.
Maine. c. 1920. *(George F. Wick)*

PLATE 5. Springtime in The Old Burying Ground.
Groton, Massachusetts.

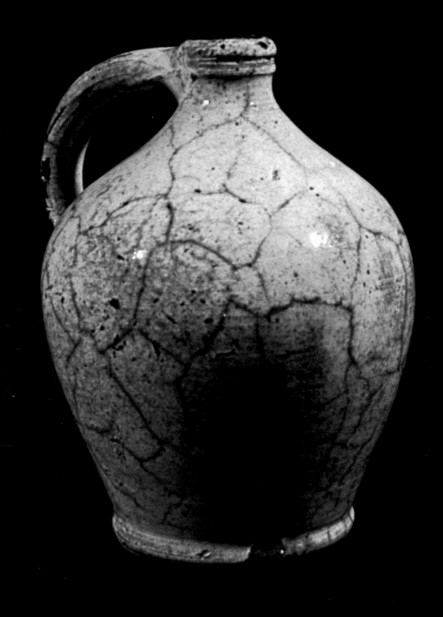

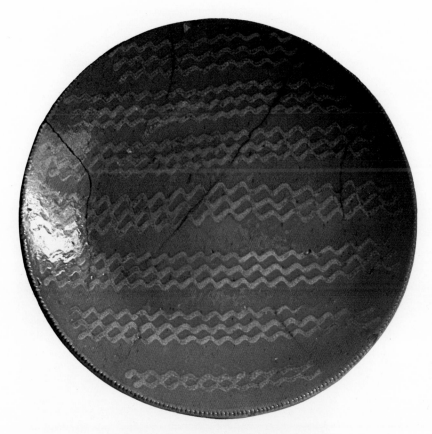

PLATE 9. Redware pie plate with slip-trail decoration.
Connecticut. 1830-1850. *(George Hammell)*

PLATE 8. Redware jug with crackled cream glaze.
Attributed to Wilcox Pottery. West Bloomfield, New York.
c. 1840. *(George Hammell)*

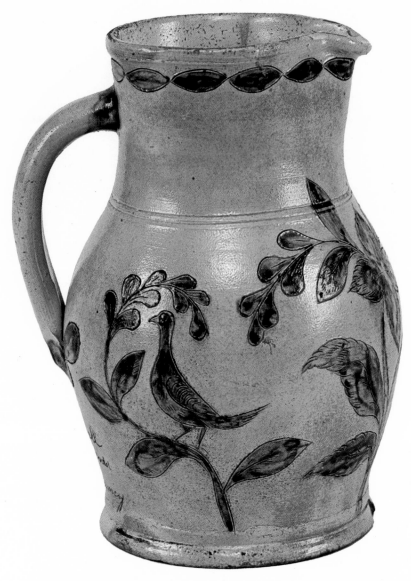

PLATE 10. Salt-glazed stoneware pitcher with incised and cobalt decoration.
Inscribed "Mary P. Hall by her friend Henry Remmey."
New York City. c. 1785. *(Howard and Catherine Feldman)*

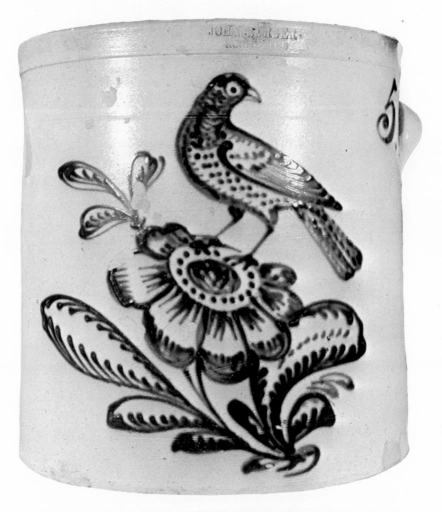

PLATE 11. Salt-glazed stoneware storage crock with cobalt decoration. John Burger. Rochester, New York. 1854-1867. *(George Hammell)*

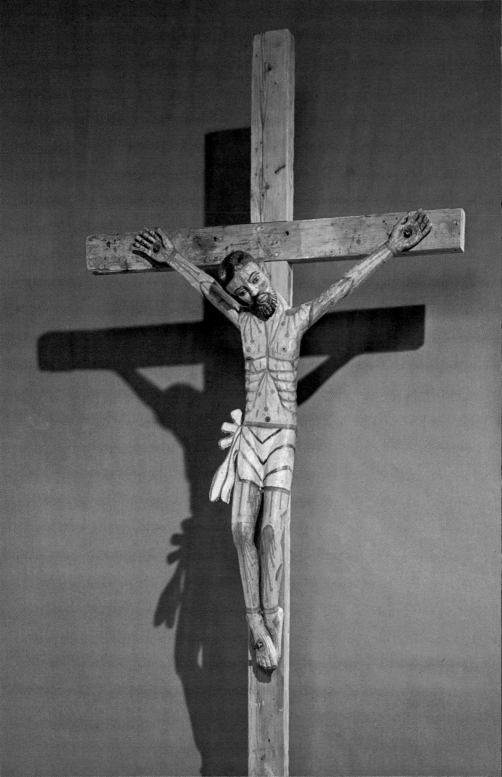

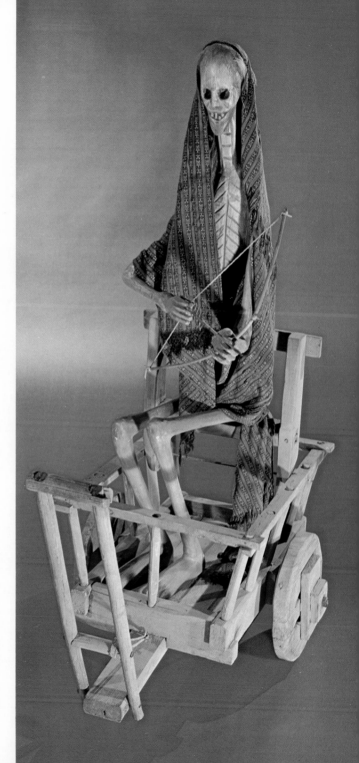

PLATE 12. *Crucifixion*.
The Santo Niño
Santero. c. 1840.
Gessoed and
painted cottonwood
root. H. 62½".
*(The Denver Art
Museum)*

PLATE 13. *Death Cart*
(Penitente).
José Inex Herra.
c. 1900.
Gessoed and
painted cottonwood
root. H. 48"
*(The Denver Art
Museum)*

PLATE 14. *The Whaler's Flag.*
Artist unknown. c. 1845.
Oil on canvas. 39″ x 95½″.
*(The Americana Collection of
Donaldson, Lufkin & Jenrette, Inc.)*

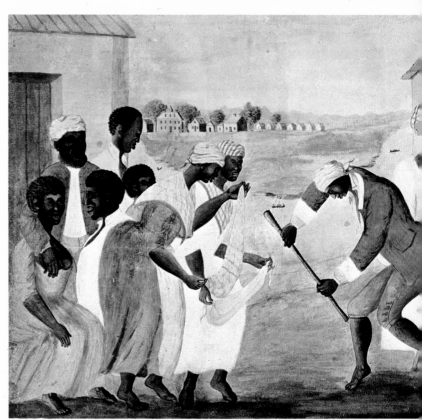

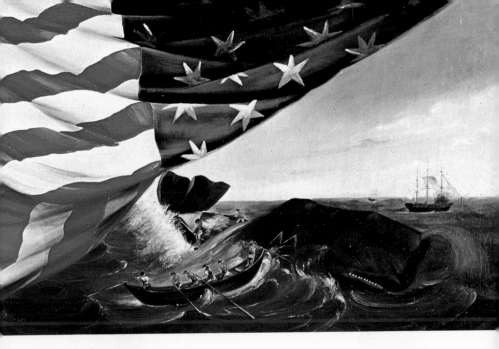

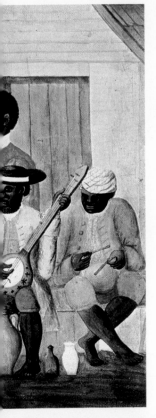

PLATE 15. *The Old Plantation.*
Artist unknown. c. 1798.
Watercolor on paper. 11¾″ x 17⅞″.
(Abby Aldrich Rockefeller Folk Art Collection)

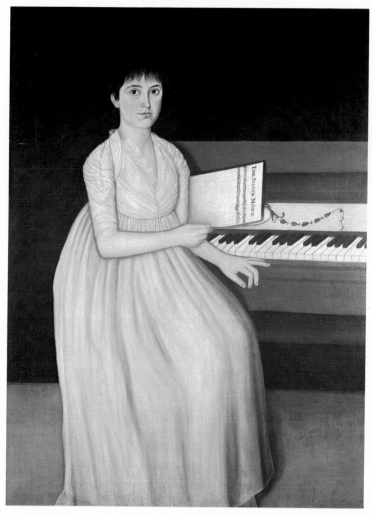

PLATE 16. *Sarah Prince*. John Brewster, Jr. c. 1801. Oil
on canvas. 50½" x 40". *(Mrs. Jacob M. Kaplan)*

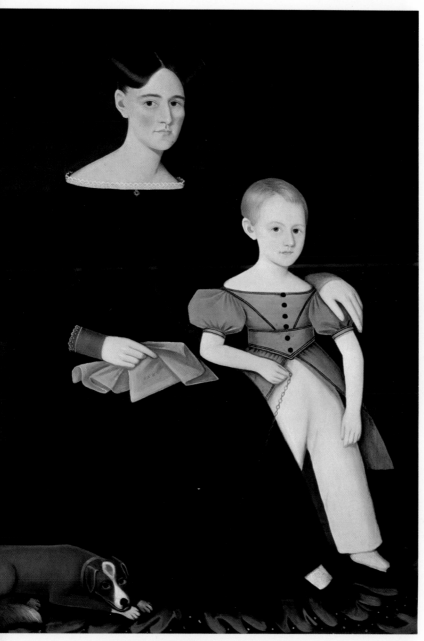

PLATE 17. *Mrs. Ostrander and Son, Titus.* Ammi Phillips. c. 1838. Oil on canvas. 58″ x 44″. *(Mrs. Jacob M. Kaplan)*

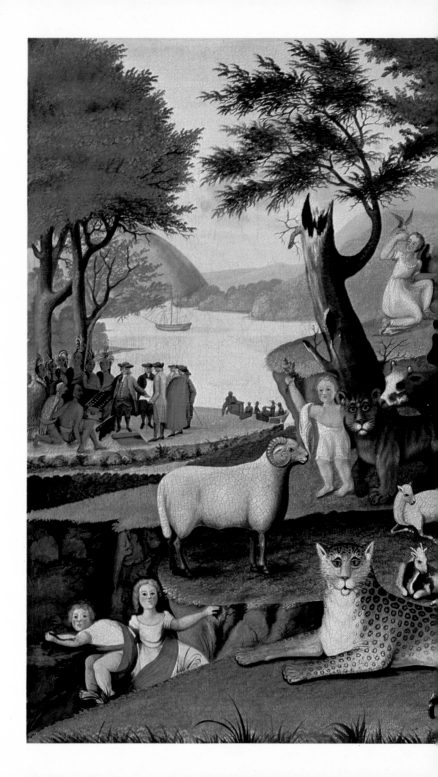

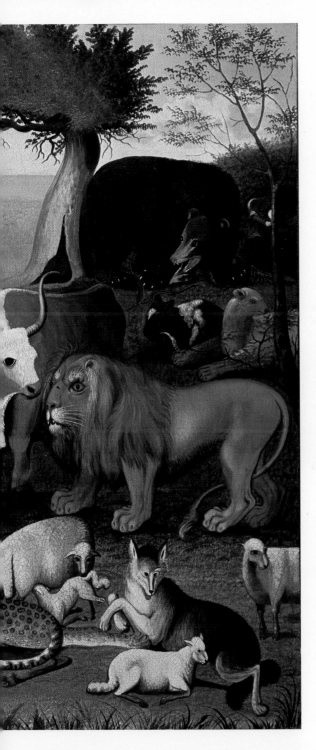

PLATE 18.
The Peaceable Kingdom.
Edward Hicks.
c. 1847.
Oil on canvas. 26″ x 29½″.
William Penn's Treaty
with the Indians is
depicted in background
at left.
(Private collection)

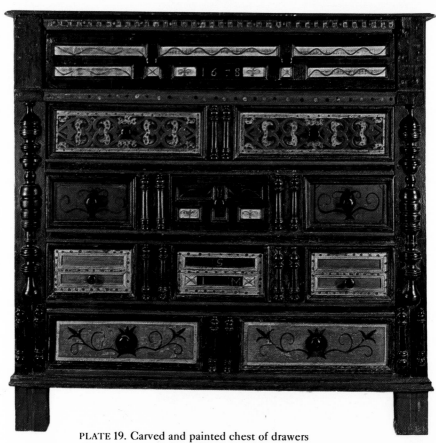

PLATE 19. Carved and painted chest of drawers
with applied split spindles. Attributed to Thomas Dennis,
Ipswich, Massachusetts. Dated 1678, the chest bears
the initials of John and Margaret Staniford. W. 44¾".
(The Henry Francis du Pont Winterthur Museum)

PLATE 20. Painted chest with drawer. Hampton, New Hampshire.
1710-1740. W. 43½". Geometric and naturalistic motifs combine
on this rare chest to create a fascinating example of
early country furniture. *(Private collection)*

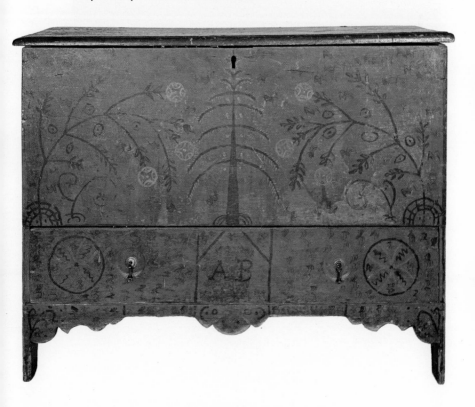

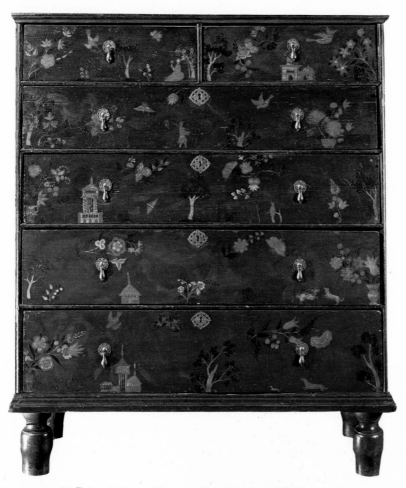

PLATE 21. Painted chest of drawers. East Windsor Hill, Connecticut. c. 1725. W. 43″. This country version of fashionable japanned furniture, which was in turn a Colonial simulation of English japanning techniques, offers much to delight the eye: birds and butterflies, astonishing architecture, a lady with a fan, and vases of flowers much in the style of contemporary needlework. *(The Metropolitan Museum of Art, Gift of Mrs. J. Insley Blair, 1945)*

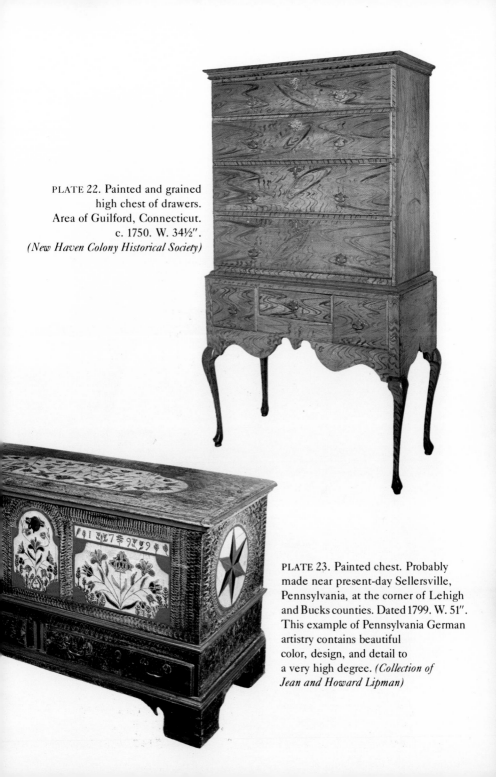

PLATE 22. Painted and grained
high chest of drawers.
Area of Guilford, Connecticut.
c. 1750. W. 34½".
(New Haven Colony Historical Society)

PLATE 23. Painted chest. Probably
made near present-day Sellersville,
Pennsylvania, at the corner of Lehigh
and Bucks counties. Dated 1799. W. 51".
This example of Pennsylvania German
artistry contains beautiful
color, design, and detail to
a very high degree. *(Collection of
Jean and Howard Lipman)*

PLATE 24. *The Talcott Family*. Deborah Goldsmith. Upper
New York State. 1832. Watercolor on paper. 14" x 18".
(Abby Aldrich Rockefeller Folk Art Collection)

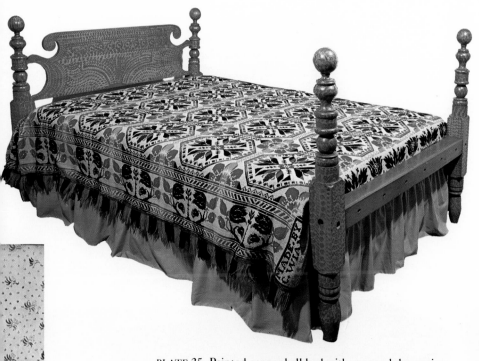

PLATE 25. Painted cannonball bed with sponged decoration.
Eastern Connecticut. c. 1835. L. 84″.
The boldness of the turned posts and the beauty of the sponging,
especially on the "swan's-neck" headboard,
make this a masterful example of the country style.
(Private collection)

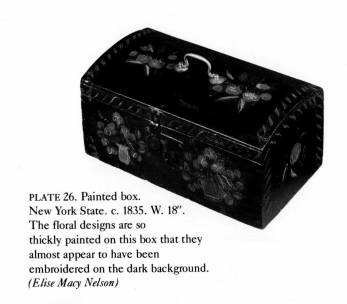

PLATE 26. Painted box.
New York State. c. 1835. W. 18″.
The floral designs are so
thickly painted on this box that they
almost appear to have been
embroidered on the dark background.
(Elise Macy Nelson)

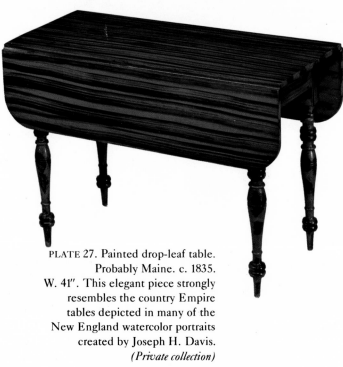

PLATE 27. Painted drop-leaf table.
Probably Maine. c. 1835.
W. 41″. This elegant piece strongly
resembles the country Empire
tables depicted in many of the
New England watercolor portraits
created by Joseph H. Davis.
(Private collection)

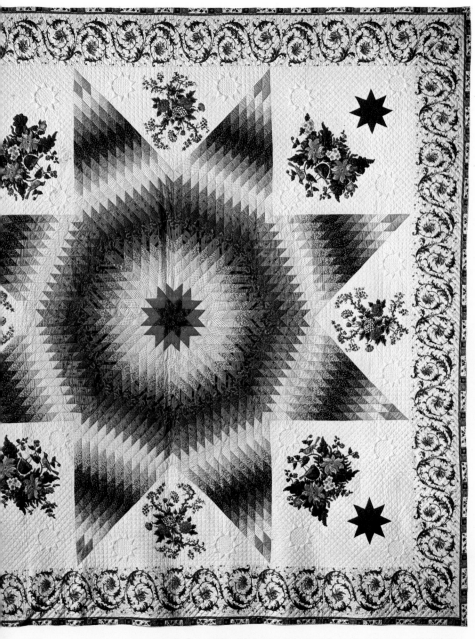

PLATE 28. Star of Bethlehem pieced and appliqué quilt. 1835-1845. 120″ x 120″. Appliqués of English flower-and-bird chintzes punctuate the spaces between the points of the pieced star. Stuffed work embellishes the white cotton field. *(The Metropolitan Museum of Art)*

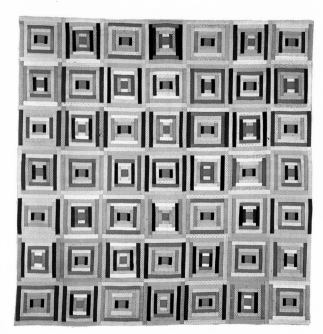

PLATE 29. Log Cabin quilt in Courthouse Steps design. Pennsylvania. c. 1865. Wool. 86½″ x 85″. The fabric strips simulate the architectural motifs of a Greek Revival building: frieze, columns, and steps.
(Gail van der Hoof and Jonathan Holstein)

PLATE 30. Appliqué quilt. Pennsylvania. Inscribed "Jennie Cleland March 1861." 83″ x 81″. The berries are rendered in stuffed work.
(Gail van der Hoof and Jonathan Holstein)

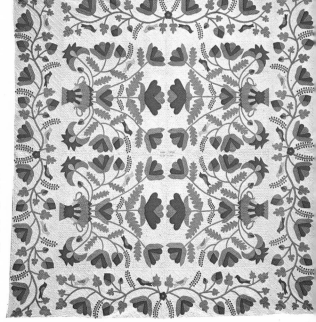

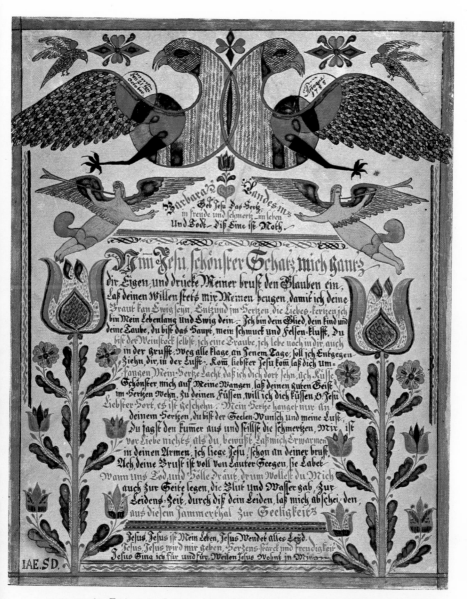

PLATE 31. Fraktur by Johann Adam Eyer. Dated 1788. Probably Bucks County, Pennsylvania. Hand drawn, lettered, and colored on paper. 10″ x 8″. See pages 150-151 for a translation of the religious text in this Fraktur. The signature IAE.SD. in the lower left corner identifies the Fraktur maker, who was a *Schuldiener* (schoolteacher). *(Private collection)*

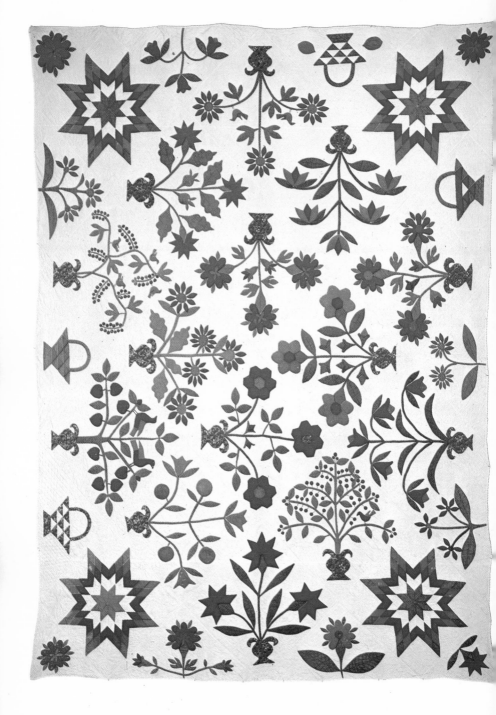

PLATE 32. Appliqué and
pieced quilt. Pennsylvania.
c. 1870. 100¾" x 73½".
(*Private collection*)

PLATE 33. *Tom Matthews*.
From the shop of Samuel A. Robb.
New York City. 1886-1895.
Painted wood. H. 54". This
sculpture shows a famous clown of
the nineteenth century who
carried on in the tradition of
Joseph Grimaldi, even to the point
of imitating his costumes.
Photograph by Frederick Fried.
(*Heritage Plantation of Sandwich,
Massachusetts*)

PLATE 34. *Morra's Shoe Repair.* Shop sign photographed by Tamara E. Wasserman at Avenue of the Americas and 16th Street, New York City. 1972.

PLATE 35. Harvest figure. Photographed by Ann Parker in New England. 1966.

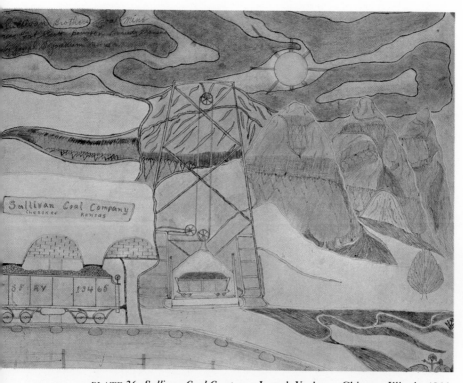

PLATE 36. *Sullivan Coal Company.* Joseph Yoakum. Chicago, Illinois. 1966.
Crayon and pen on paper. 18″ x 24″. *(Herbert W. Hemphill, Jr.)*

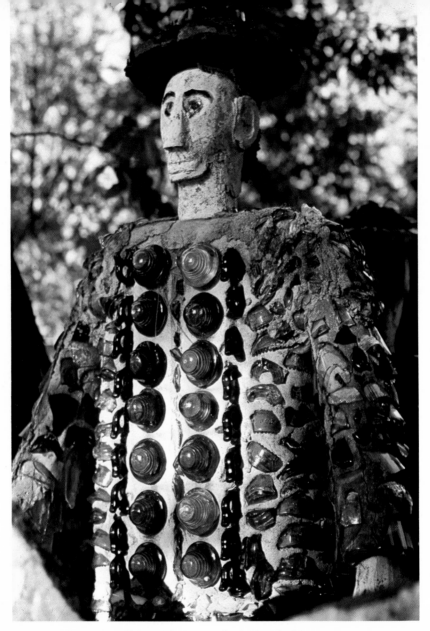

PLATE 37. Figure from *Wisconsin's Concrete Park*. Fred Smith.
Phillips, Wisconsin. Begun in 1950. The Concrete Park consists of 300 figures
that are made of concrete and set with shards of bottle glass, mirrors,
and glass insulators from telephone poles.

were patched, and reused until they disintegrated, so that only a few pre-nineteenth-century fragments remain. The Spanish exerted a major influence on the native Indian textile industry, but the two groups developed distinct textile traditions that survive side by side to this day. These traditions sometimes create textiles that seem very similar at first glance, but those familiar with the distinctive weaves and patterns of each tradition can easily distinguish among them.

The Pueblo Indians grew cotton and wove textiles long before the arrival of the Spanish. Archaeological finds at isolated sites in the Southwest confirm the age and complexity of this native industry. Coronado's expedition reported the natives wearing finely woven and brightly "painted" blankets, capes, and aprons. Later, colonial tribute was most often paid with native-made textiles. Unfortunately, early inventories that list large quantities of tribute textiles never specify materials, weaves, or designs. We do know that the imported longhaired Spanish sheep were immediately adopted by the Indians, and that woolen textiles had almost completely replaced native cotton textiles by 1775.

Using spinning wheels and looms made of local pine, the Spanish colonists themselves produced simple, durable cloth. The most common textile, woven for household use and trade, was a plain-weave wool homespun known locally as *sabanilla*. It could be finely woven for clothing or loosely woven for bedrolls and mattress covers. After weaving, it was usually dyed in solid colors with imported indigo blue or red trade pigments.

Sabanilla was used as the foundation for elaborately embroidered altar cloths (fig. 51), bedspreads, and wall hangings. These embroideries take their name, *colcha*, from the stitch used in applying the decorative threads. The *colcha* stitch, a long face-stitch held in place by short diagonal cross-tack stitches, appears to be a New Mexican invention, for it was not used in either Spain or Mexico.

51. Detail of overall colcha-embroidered altar cloth. c. 1860.
Sabanilla with colcha embroidery. 79″ × 53″. (*The Denver Art Museum*)

52. Detail of Taos style jerga carpet. c. 1900. Wool, diagonal twill weave.
27″ × 17′. (*The Denver Art Museum*)

The finest *colchas* are completely covered with embroidered threads. Others resemble crewel embroidery, which does not cover the complete foundation cloth, and they are decorated with vine patterns of leaves and flowers. These examples suggest that the technique was developed in imitation of imported Chinese silk embroideries on church vestments.

Another local textile known as *jerga, gerga,* or *xerga* was a coarse wool sackcloth with a diagonal or herringbone twill weave (fig. 52). Always woven in two colors, *jerga* is easily identified by its plaid or checkered patterns. Since it was woven in long narrow strips, it could be cut, folded, and seamed for sacks or sewn together to form room-size rugs that were nailed to the adobe floors. After milled lumber was introduced in the late nineteenth century and wood floors became common, *jerga* was used for scatter rugs.

The wearing-blankets that served the Spanish colonists as overcoats by day and bedcovers by night are known today as Rio Grande blankets to distinguish them from Navajo blankets, which they often resemble. These prestigious and fashionable elements of costume received constant wear and were frequently replaced with the newest patterns and colors. Since Rio Grande blankets were not collected until the early years of the twentieth century when they became fashionable as furniture covers and throw rugs, very few surviving examples can be dated before 1850.

Wool, hides, and woolen textiles were New Mexico's major exports during colonial times. Yet, local weaving had so deteriorated by 1806 that the government in Mexico sent professional weavers to the colony to reestablish and modernize the art. The massive harness looms on which Rio Grande blankets were made and the blankets themselves seem to be derived directly from late eighteenth-century Mexican prototypes. Unlike the Mexican poncho, however, the Rio Grande blanket never had a central hole for the head.

Woven in basic tapestry weave, which produces identical patterns on both sides of the fabric, Rio Grande blankets were frequently made in two pieces and sewn together. When they were woven as one width, threads were carried over the center and around the selvedges where extra multiple warps were grouped together, forming slight ridges at the center and sides. These blankets never exhibit the two characteristics that make Indian-made textiles immediately identifiable: looped or rolled yarn trim at the selvedges, and lazy stitches caused by working one color or area without maintaining the same level across the entire loom.

The Rio Grande blankets have three recognized types of design. One group, the formative style, consists of lateral stripes and bands resembling Pueblo blankets of the same time period. The second type, characterized by large, central diamond-shaped patterns (fig. 53), was adapted from Mexican blankets named

53. Detail of Saltillo style Rio Grande wearing blanket. c. 1860. Wool tapestry weave. Area photographed 25″ × 30¼″. (*The Denver Art Museum*)

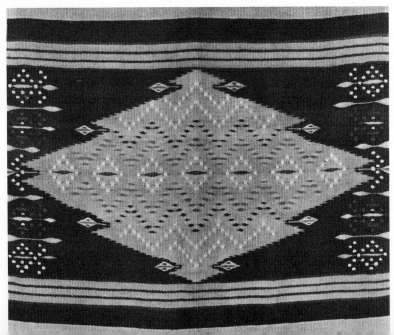

Saltillos after one of the major weaving centers in Mexico. The Saltillo design was probably inspired by Oriental textiles, particularly Kashmir shawls, which were fashionable imports in the mid-nineteenth century. The third, the Vallero style, incorporated earlier designs into complex patterns around large eight-pointed stars. Patterns composed on diagonals and zigzags were easily woven by the tapestry weaver. Inca textiles from ancient Peru, also of tapestry weave, look surprisingly similar and also are characterized by eight-pointed stars. These star designs became very popular during the late nineteenth century as a favored motif on patchwork quilts.

Rio Grande blankets are roughly dated by the types of dyes and yarns used. Natural dyes such as indigo, cochineal, or logwood are dated earlier than commercial colors and yarns. Saxony yarns and aniline dyes appear on the last examples that date from the very end of the nineteenth century.

CONCLUSIONS

New Mexico was annexed to the United States in 1848 bringing military protection that encouraged expansion from Taos into southern Colorado. The construction of Fort Garland, Colorado, in 1859 and the end of the Civil War in 1865 brought waves of settlers, miners, and traders into the long isolated valleys. With them came new fashions, materials, ideas, and social customs. New Mexico's physical isolation was now over but the Hispanic villages continued many of their old traditional ways relatively unchanged until World War II.

Recent interest in ethnic studies is helping to foster a broader awareness and appreciation of our cultural heritage. When we compare the material evidence left by distinct elements in our society we can begin to appreciate the richness and variety of our cultural achievement. The distinct flavor and the unique character

of New Mexico's folk traditions has been deeply influenced and subtly colored by almost 300 years of European rule and by a thousand years of fascinating indigenous civilizations. Next to the American Indian, the folk artists of New Mexico are now recognized as the creators of the most original and powerful visual traditions of the cultural heritage we all share as Americans.

FURTHER READING

BOYD, E. *The Literature of Santos.* Dallas, Tex.: Southern Methodist University Press, 1950.

————. *Popular Arts of Spanish New Mexico.* Santa Fe, N.M.: Museum of New Mexico Press, 1974.

Denver Art Museum. *Santos of the Southwest, The Denver Art Museum Collection.* Denver, Colo., 1970.

ESPINOSA, JOSE E. *Saints in the Valleys.* Rev. ed. Albuquerque, N.M.: University of New Mexico Press, 1960.

KUBLER, GEORGE. *The Religious Architecture of New Mexico in the Colonial Period and Since the American Occupation.* Colorado Springs, Colo.: The Taylor Museum, 1940.

STEELE, THOMAS J. *Santos and Saints.* Albuquerque, N.M.: Calvin Horn, 1974.

WILDER, MITCHELL A. and BREITENBACH, EDGAR. *Santos, the Religious Folk Art of New Mexico.* Colorado Springs, Colo.: The Taylor Museum, 1943.

AMERICAN FOLK PAINTING

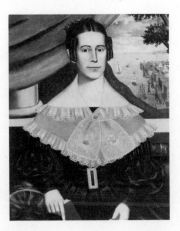

by

Mary Black

The record of folk painting in America is almost as long as the record of permanent settlement by Europeans. But the renaissance and reappraisal of folk art by critics and collectors is a twentieth-century phenomenon that has been gathering momentum since the 1920s. It is a remarkable renaissance. The way in which works by primarily untrained, self-taught painters are viewed today is quite different from the practice and purpose that led to their initial creation. Although the large canvas *The Whaler's Flag* (plate 14) may have been painted as a memorial of a specific event or in recognition of a heroic deed, today we recognize it as a bravado creation with great aesthetic appeal. The capture of a whale was a popular subject for both academic and folk artists, and this view may well have been based on a print. The great flag, draped as a curtain at the left, is a dramatic addition to a traditional subject.

From the last half of the seventeenth century up to about 1850, when the camera came into common use, folk paintings were regarded as practical records that captured the faces and farms and interests of the patrons of country artists. Almost without exception, the professional artist in this early period was responsive to the society and environment that he portrayed. In contrast, talented amateurs created works that were flights of fancy to foreign lands, or to heaven itself beyond the universe. The most notable exception was the carriage and sign painter who was also a Quaker preacher, Edward Hicks.

An imaginatively designed and naïvely conceived genre painting by an anonymous artist of the late eighteenth century illustrates the color, vitality, and knowledgeable use of painting materials that is characteristic of all great folk art: in *The Old Plantation* (plate 15) boldly accented and individualized figures celebrate what may be a wedding. The clothes are American while the turbans, scarves, stick ceremony and musical instruments are African. The movement

of the three central figures is most unusual in folk art where static poses predominate.

When twentieth-century artists stimulated the appreciation and collecting of nineteenth-century folk art and the creation of contemporary folk art, the contexts of society, art collecting, and criticism were wholly altered from early ideals. Like the widening pupil of an eye expanding in a dark room, folk painting took on new meaning. Faithfully painted records were now judged by aesthetic standards that had not been applied by either the original artists or patrons. At first, as hidden or long-forgotten works began to be uncovered, the folk artist far outweighed his subjects in anonymity, and identification of artist, face, or scene was of less importance than aesthetic appeal. This remains the twentieth-century's judgment and chief basis for selection, but this standard is now augmented by recognition of the original purpose, and often of the subject and artist as well.

That there was ample patronage of the folk painter in early New England and New York is a matter of record; today many works dating from the mid-seventeenth century are known. There were craftsmen-painters such as Evert Duyckinck the First in New York and Thomas Child in Boston, and the anonymous portrait painters of the Freake, Gibbs and Mason families of Boston. In the early eighteenth century the first school of painting in America developed along the reaches of the Hudson, and one of its members, whose known portraits date from about 1715 to about 1725, deserted his Albany-area patrons to travel to Newport, Rhode Island, and Jamestown and Williamsburg, Virginia, in 1722 and 1723. In Williamsburg he painted young Frances Parke Custis (fig. 54). To the identification of the artist, the distinctive style of that portrait is as important as the inscription, in a handwriting familiar from the upper Hudson, *Aetatis Suae—14–1723*. The artist remains anony-

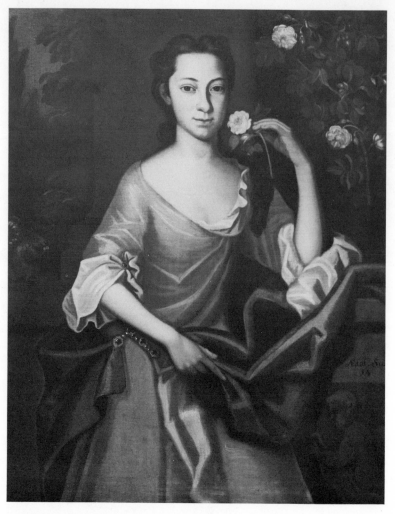

54. *Frances Parke Custis* (age 14). "Aetatis Suae Limner." 1723.
Oil on canvas. 37" × 29½".
(*Washington-Custis-Lee Collection, Washington and Lee University*)

mous, but from his use of the old Latin phrase for recording the age of his subject and the year of the painting, he is called the Aetatis Suae Limner. He returned north, and in Albany and Schenectady, the area of his first success, portraits are the documents

that record his work from 1724 to about 1726, after which he vanished from the scene.

On the upper and middle Hudson his successor in the portrait line was Pieter Vanderlyn (1687–1778), the only artist currently identified in a group of at least nine eighteenth-century New York portrait painters. Grandfather of the American artist John Vanderlyn (1775–1852), Pieter came to New York from Holland in 1718, but his earliest-known portraits are of Albany-area subjects in 1730. Outstanding examples of his work are the portraits of Leendert and Catharina Gansevoort (figs. 55 and 56). Thinly painted and set in elegant poses borrowed from mezzotint sources, the Gansevoorts are important icons in the history of American art. In a spirit of playfulness the backgrounds of the pair illustrate a rebus on their last name, red-footed geese sport in a pond in the man's portrait and a fort is the principal background in the woman's; "goose-fort" or in Dutch, "Gansevoort."

As the movement toward rebellion against England grew, portraits proliferated and a few landscapes were painted. Following the Revolution and the establishment of the new republic, the folk artist began to create an unprecedented painted record. Family portraits lined (and in number, perhaps, warmed—in the manner of medieval tapestries) halls, best rooms, parlors, and bedrooms of the new states. Possessions were catalogued in paint, and family histories were set down in glowing, illuminated records. Hollow-cut stencils were registered in pre-designed theorems that were mostly utilized as exercises for schoolgirls·or "for fancy" by their mothers. From the abundance of folk art that still exists—collected, noted, or still unseen—it seems evident that almost everyone either painted or ordered paintings.

Records other than paintings exist. Diaries of artists and patrons, receipts, letters, and journals all attest to the proliferation of paintings on canvas and of watercolors on paper. When two por-

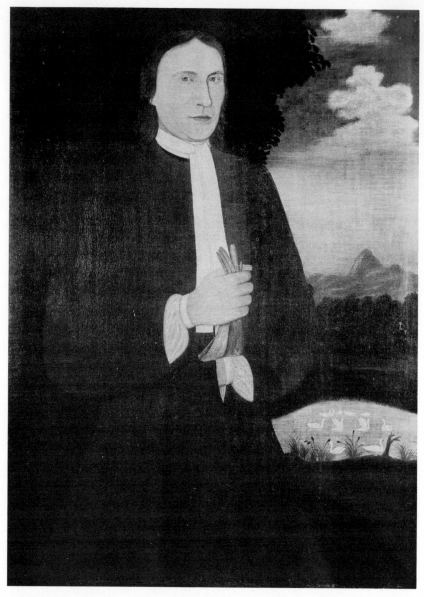

55. *Leendert Gansevoort*. Pieter Vanderlyn. Early eighteenth century.
Oil on canvas. 47½″ × 35½″. Photograph courtesy Frick Art Reference
Library. (*Collection Mr. and Mrs. Stephen C. Clark, Jr.*)

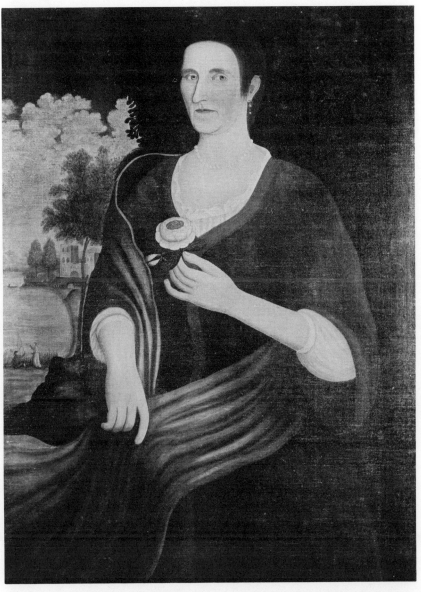

56. *Caterina Gansevoort.* Pieter Vanderlyn. Early eighteenth century.
Oil on canvas. 47½″ × 35½″. Photograph courtesy Frick Art Reference
Library. (*Collection Mr. and Mrs. Stephen C. Clark, Jr.*)

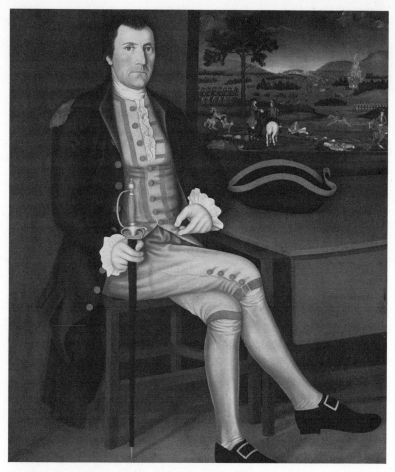

57. *Captain Samuel Chandler*. Winthrop Chandler. c. 1780.
Oil on canvas. 54⅞″ × 47⅞″. (*National Gallery of Art;
Gift of Edgar William and Bernice Chrysler Garbisch*)

traits of one large family are known, it is almost certain that less
handsome members were also painted. The numbers of canvases
increase as artists approach our time, but even eighteenth-century
painters had long schedules of works that we now know. Today
nearly one hundred paintings are attributed to the anonymous
Aetatis Suae Limner; more than twenty to Pieter Vanderlyn; and
more than fifty to the group known as the Duyckinck Limners of

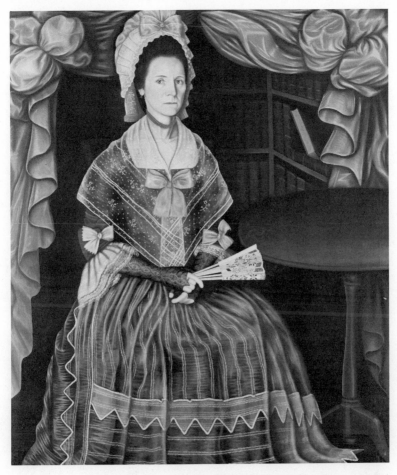

58. *Mrs. Samuel Chandler*. Winthrop Chandler. c. 1780.
Oil on canvas. 54¾″ × 47⅞″. (*National Gallery of Art;
Gift of Edgar William and Bernice Chrysler Garbisch*)

New York City.

As new states were established, folk painters whose territories
overlapped and interlocked served their terms in country courts.
The first to appear was Winthrop Chandler (1747–1790) whose
influence can be traced through two generations of country painters.
Captain Samuel Chandler was the artist's brother and the portrait
of him and his wife (figs. 57 and 58) are representative of Chan-

dler's monumental painted figures, giving evidence of the folk painter's delight in detailing the possessions and interests of his subjects. A military action is seen in the background in Captain Chandler's likeness, while both portraits show possessions that indicate a more than comfortable position within their society.

Winthrop Chandler influenced a parade of later limners that included Simon Fitch, John Brewster, Jr., Nathaniel Wales, and J. Brown. They were then the teachers of others, in fact or by portrait proxy. Of the second wave, deaf and mute John Brewster, Jr., (1766–1846) was the most interesting and most prolific. He moved between family homes in Maine and Connecticut and, in the early nineteenth century, stopped for a time in Newburyport, Massachusetts. Brewster's masterpiece is the portrait of Sarah Prince (plate 16); large in scale, simply conceived, it is a study in cream, brown, and dark tones. Ironically, Brewster's subject is seated at the keyboard of a piano on which is a sheet of music, "The Silver Moon," whose notes—played or sung—could never be heard by the painter.

Employing a similar palette and style, an artist known only by his first initial and last name, J. Brown, produced a commanding full-length portrait of another young woman of the new republic, whose wary glance contrasts with the simplicity and directness of Sarah Prince. Laura Hall Kasson (fig. 59) exhibits her handsome self-possession in another landmark portrait at the beginning of the folk artist's heyday.

Ammi Phillips (1788–1865) painted more than 400 portraits that are known today. His younger contemporary, Erastus Salisbury Field (1805–1900), produced a comparable number of works (enlarged in subject to include religious and historical scenes). The New England and eastern New York territory of the two men overlapped. Phillips, seventeen years older than Field, began painting about 1811 and pursued his craft for more than fifty years. At

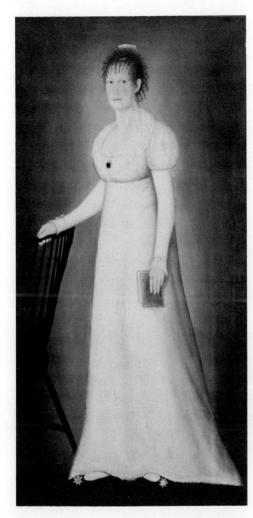

59. *Laura Hall Kasson* (age 18).
J. Brown. c. 1808.
Oil on canvas. *6′ × 3′.*
(*New York State Historical
Association*)

the height of his career (about 1833) he painted one of the few
double portraits known to be his work, the full-length likenesses
of Rachel Ann Maria Overbaugh Ostrander and her son, Titus
(plate 17). Phillips's painting style is incisive, crisp, and highly
stylized. Costumes and accessories enrich the scene, which is an
interior with no windows.

Field's method was quick and accurate; emphasis was placed

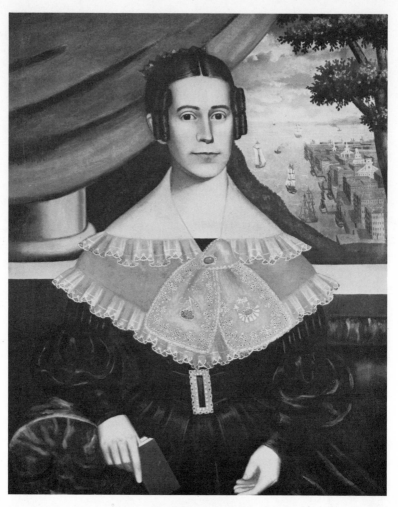

60. *Clarissa Gallond Cook*. Erastus Salisbury Field. c. 1839. Oil on canvas. 34″ × 28″. (*Shelburne Museum, Inc.*)

on the personalities of his subjects in contrast to Phillips's careful delineation of features. Field's career extended from 1824 to the mid-1890s, although when the camera came into common use he, like other portrait painters, began to lose his profitable vocation to the new mechanical marvel. About 1839, at the height of his powers, Field recorded the likeness of Clarissa Gallond Cooke (fig. 60), as

he had done of her parents, sisters, brothers-in-law, nephews, and nieces; a city on a river occupies the background in this forthright and beautiful portrayal of a young woman.

In Pennsylvania, Jacob Maentel (1763–1863) worked as a painter of watercolor portraits in the tradition of the Pennsylvania German Fraktur or record maker. Maentel widened the horizon of traditional Fraktur painting to include small-scale portraits of his neighbors and relations. Almost all are full-length likenesses. Among his more ambitious efforts are the pair, *General Schumacher and His Daughter* (figs. 61 and 62), painted early in his career. Demonstrating a practice he frequently employed, he pictured the girl against a fully developed interior and portrayed her father in a landscape, a genre scene of a battle in which he had taken part in the War of 1812. Both paintings are side views, which was Maentel's usual practice from about 1800 to 1820. Later on, most of his figures were placed full front, facing the artist.

Edward Hicks (1780–1849), originally trained as a carriage and fancy painter, turned to easel painting almost as an avocation at about the time that he adopted the Quaker belief of his foster parents. In the mid-1820s he undertook the first of his many versions of *The Peaceable Kingdom*, unquestionably the most familiar subject in American folk art. All his versions differ one from another, but each was based on a prophesy in the Book of Isaiah foretelling peaceful existence between wild and domesticated beasts led to a harmonious state by a little child. In most of Hicks's Kingdoms, William Penn's Treaty with the Indians is a minor theme adopted by the artist from a print after Benjamin West's version. An 1844 version of *The Peaceable Kingdom* was painted for Joseph Watson, Hicks's Newtown, Pennsylvania, neighbor, and sold to him with frame for $21.75. One of the latest in the series, painted about 1847, is illustrated in plate 18.

The written journal of the crippled New England folk

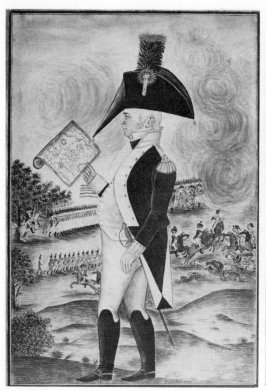

61. *General Schumacher.*
Jacob Maentel. c. 1812.
Pen and watercolor. 14½″ × 9½″.
(*Collection Edgar William and
Bernice Chrysler Garbisch*)

62. *General Schumacher's Daughter.*
Jacob Maentel. c. 1812.
Pen and watercolor. 14½″ × 9½″.
(*Collection Edgar William
and Bernice Chrysler Garbisch*)

painter, Joseph Whiting Stock, records fourteen years of painting
and documents the completion of more than 900 paintings—a veri-
table avalanche. His New York advertisements contain the record
of one year in which he completed 100 portraits of Middletown,
New York, subjects. Contemporaneously, the Millerite, William
Matthew Prior, and his artist in-laws, the Hamblens, account for
an extraordinary number of portraits, polished or unpolished accord-

ing to price, which issued from their "painting attic" in South Boston.

For the most part, the untutored folk artist worked for his peers in a society in which all were members. If he moved to new territory it was almost always one in which relatives or friends already lived. As a consequence, in establishing bodies of work for individual artists, the chronology of events related to and recorded in paintings helps to clarify the artist's work pattern and frequently identifies additional work painted by the same person.

The close relations between folk artist and patron presumed a middle-class society in which there was sufficient leisure to think of enhancing the quality of life. For this reason, the great preponderance of professional folk painters worked in the small towns and rural areas of New England and in the middle Atlantic region where a secure middle class was most numerous.

Although the heyday of the folk artist is past, self-taught painters work on, some profitably, some for the fun of it. The best painters nowadays are sometimes as isolated geographically as were their nineteenth-century peers. Some today demonstrate the same constriction, or infirmity, or blossoming forth in old age, as did the early painters. Today's untutored painters—whose ranks might also include some far less trained by repetition than were earlier practitioners—carry on the old tradition. But with this difference: today they are judged by aesthetic standards. Yesterday's artists served their neighbors and relatives by providing useful and practical records.

FURTHER READING

BLACK, MARY. *Ammi Phillips; Portrait Painter, 1788–1865* (with a catalogue by Barbara C. & Lawrence B. Holdridge). New York: Clarkson N. Potter, 1969.

————, and LIPMAN, JEAN. *American Folk Painting*. New York: Clarkson N. Potter, 1966.

DREPPARD, CARL W. *American Pioneer Arts and Artists*. Springfield, Mass.: Pond-Ekberg Co., 1942.

FORD, ALICE. *Pictorial Folk Art, New England to California*. New York and London: The Studio Publications. 1949.

————. *Edward Hicks, Painter of the Peaceable Kingdom*. Philadelphia: University of Pennsylvania Press, 1952.

LIPMAN, JEAN, and WINCHESTER, ALICE. eds. *Primitive Painters in America 1750–1950*. New York: Dodd, Mead & Co., 1950. Reprint. Freeport, N.Y.: Books for Libraries Press, 1971.

LITTLE, NINA FLETCHER. *The Abby Aldrich Rockefeller Folk Art Collection*. Boston: Little, Brown and Company, 1957.

AMERICAN COUNTRY FURNITURE

by

Robert Bishop

Country furniture, like all good folk art, is constantly fascinating, for it often possesses that individual touch of form, proportion, detail, or handling of paint that at once marks the piece as worthy of special attention. The term *country furniture* is subject to several interpretations. In the August 1953 issue of The Magazine *Antiques* an attempt was made to distinguish between sophisticated cabinetry and country craftsmanship. Frank O. Spinney stated: "To think of country furniture as the cabinetmaker's equivalent of what has been called folk, popular, provincial, or primitive in the field of art may

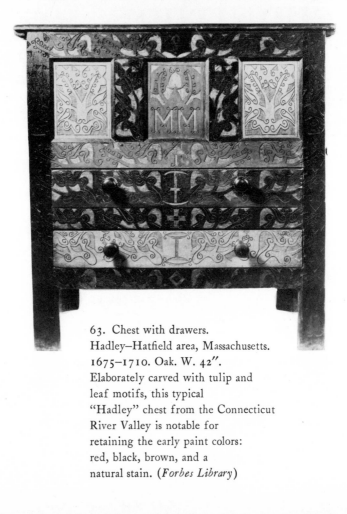

63. Chest with drawers.
Hadley–Hatfield area, Massachusetts.
1675–1710. Oak. W. 42".
Elaborately carved with tulip and
leaf motifs, this typical
"Hadley" chest from the Connecticut
River Valley is notable for
retaining the early paint colors:
red, black, brown, and a
natural stain. (*Forbes Library*)

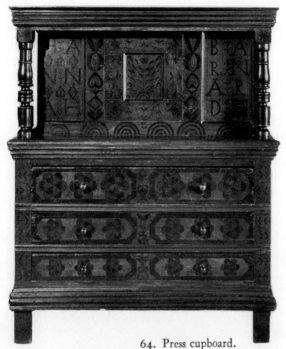

64. Press cupboard.
Hadley area, Massachusetts. c. 1715.
Oak, pine, and maple. H. 61⅛″.
This press cupboard with its
distinctive geometric and
naturalistic painted designs was
probably made for Hannah Barnard at
the time of her marriage in 1715.
Her name appears to the left
and right of the central panel.
(*Greenfield Village and
Henry Ford Museum*)

be a useful concept." Once again, in the March 1968 issue, *Antiques*
published a symposium on country furniture. Nina Fletcher Little,
the noted collector and connoisseur of American country furniture,
said: "Country pieces . . . may be either accomplished or naïve
and inevitably exhibit many gradations of quality and style."

We should not make the mistake of assuming that because a piece of furniture was made by a rural cabinetmaker the result is necessarily crude or lacks a sense of style. Far from it. Crudity is often found, of course, and sometimes it is made more palatable by having an interesting painted surface. But, as noted above, the appeal of country furniture comes from the fact that it often shows unusual character, style, and individuality. We are not stunned by the beauty of wood, carving, and the general air of expensive sumptuousness often found in the furniture made in Boston, Newport, New York, Philadelphia, Baltimore, and Charleston. Instead, country furniture usually provokes a smile of delight because of its idiosyncrasies. Consider, for instance, the Chippendale chair in blue-green paint from New Hampshire (fig. 68). The qualities that make this chair a masterpiece of country art are expertly summarized by Dean A. Fales, Jr., in his *American Painted Furniture:* "Its elements practically defy description; but the exaggerated ears, shells on the crest and skirt, and cutout scrolls in the splat that are echoed in the scalloping of the skirt are but a few of the parts that make up such a hopelessly wonderful, rural whole." Look also at the Sheraton desk with sliding doors (fig. 72). Not only do the shapes of the many drawers become an important part of the over-all design, but also the imaginative silhouetting of the pigeonholes, the scrolling of the skirt, and the inspired handling of the curly maple combine to make this piece sing with style. Curly maple was frequently used by country craftsmen in the nineteenth century, since it was highly prized for its rich, figured grain.

Many other fine examples of country pieces were left in the natural wood (figs. 67, 70, 71, and 73). The very handsome secretary-desk (fig. 67) is made of cherry in the Queen Anne style, and the table (fig. 73) was made of bird's-eye maple about 1835. The boldly scrolled legs make the table look as if it were ready to spring into the air.

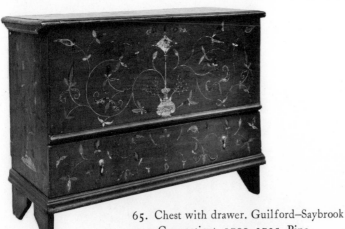

65. Chest with drawer. Guilford–Saybrook area, Connecticut. 1700–1725. Pine. W. 47½″. The urn sprouting delicate, symmetrical tendrils and leaves on the front of this blanket chest is typical of the painted decoration used in the Connecticut shore area in the early eighteenth century. Another motif featuring crowns, roses, and thistles surrounding a central fleur-de-lis is also found on chests from this region. (*The Metropolitan Museum of Art*)

66. Chest with drawers. Probably Massachusetts. c. 1730. W. 38″. Note the distinctive shaping of the front and back feet. The crude but effective red-and-black paintwork makes a particularly strong statement. (*Old Sturbridge Village*)

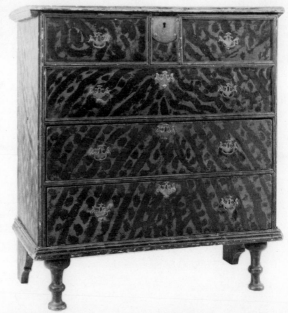

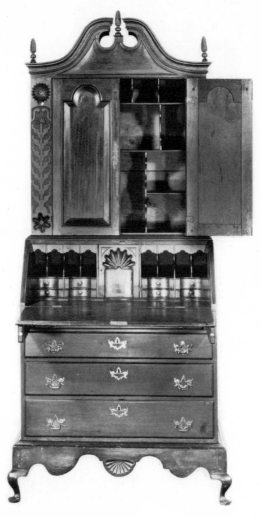

67. Queen Anne secretary-desk-and-bookcase-on-frame. Probably Hartford, Connecticut, area. 1725–1750. Cherry. H. 87¼″. This unique piece bridges the gap between the seventeenth-century and the Queen Anne style. The carved leafage on a punched background is reminiscent of the carving found on seventeenth-century chests and on many doorways found throughout the Connecticut River Valley. The short stubby cabriole legs with pad feet are often called bandy legs. The arched tombstone panels in the doors are typical of the Queen Anne period. (*Greenfield Village and Henry Ford Museum*)

68. Chippendale side chair.
Attributed to John Dunlap,
Bedford, New Hampshire. c. 1780. H. 45″.
Painted dark blue-green.
(*The Henry Francis du Pont
Winterthur Museum*)

By the mid-eighteenth century many of the half-timbered frame houses, the first homes of the German settlers in Pennsylvania, were replaced by fieldstone farmhouses. The stucco-and-beam-ceilinged room (fig. 70), now installed in the Winterthur Museum, comes from a house built in Wernersville, Pennsylvania, in 1755. Made of walnut, a wood that was popular with the Pennsylvania Germans, the furniture includes a tall case clock, a *schrank* or wardrobe, a sawbuck or trestle table, and plank-bottom chairs with hearts cut into the backs. The forms of these pieces show the influence of the furniture left behind in Germany when immigrants came to Pennsylvania in the eighteenth century. Note also the painted chest and box situated between the windows.

The majority of country furniture was originally either plain painted (like figure 68) or painted and decorated like many of the pieces that illustrate this article. The quality of the painted surface on a piece accounts for much of its individuality, desirability, and value for collectors today. Paint was used in many ways: on the Hadley chest (fig. 63) the red, black, and brown pigments help give a sense of unity to the elaborate, embroiderylike carving on the surface. On the Hannah Barnard press cupboard (fig. 64) the decoration is chiefly an exercise in geometry, whereas that of the

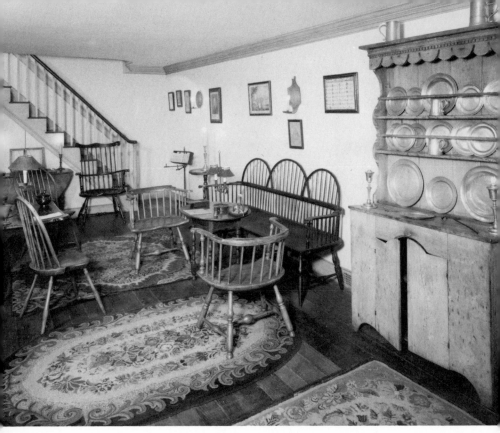

69. Museum installation. The Commons Room at Winterthur showing a variety of eighteenth-century Windsor chairs, including two low-backs, a bow-back side chair, a high-back armchair, and a triple bow-back settee. Note the tombstone-shaped doors in the lower section of the pewter cupboard.
(*The Henry Francis du Pont Winterthur Museum*)

pieces shown in figures 66, 77, 78, and plate 25 clearly demonstrates paint for paint's sake. The box (fig. 77) is a fine example of the technique known as "vinegar painting," and the sponged decoration on the superb cannonball bed (plate 25) creates a vibrant surface. One can often find nineteenth-century furniture that has been painted and grained to resemble wood, but eighteenth-century examples are rare indeed; so the Queen Anne high chest (plate 22) is remarkable for having retained its original, slapdash graining.

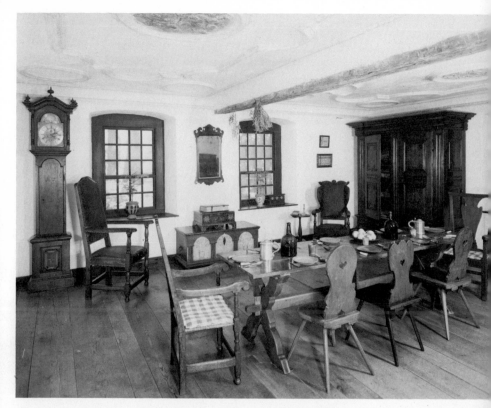

70. Museum installation. This handsome room from Wernersville,
Pennsylvania, contains many fine examples of the sturdy walnut furniture
used by the Pennsylvania Germans in the eighteenth century.
(*The Henry Francis du Pont Winterthur Museum*)

Naturalistic motifs were much used to delight the eye on both
large and small forms. Note the sprightly leaf-and-tendril decora-
tion that enlivens the chest with drawer (fig. 65), the bending trees
framing the central tree (plate 20), the splendid floral decoration
on the Pennsylvania German chest (plate 23), and the painted
flowers on the domed box (plate 26) that strongly resemble crewel
embroidery.

The color combination of red and black appears countless times

on painted furniture. Dean Fales points out in his book that in the eighteenth century these colors were, in addition to white lead, both the easiest to procure and also well suited as furniture paints. These are the colors used to such great effect on the Staniford chest of drawers (plate 19). Dated 1678 and generally attributed to Thomas Dennis of Ipswich, Massachusetts, this piece uniquely sums up the American seventeenth-century style as interpreted by a rural cabinetmaker. Red and black also boldly stripe and dot an early New England chest (fig. 66). In the nineteenth century these same colors were often used to simulate the grain of rose-

71. Hepplewhite sideboard. Providence, Rhode Island. 1790–1800. Cherry and mahogany with maple and ash inlay. L. 69⅜". Country furniture is often elaborately inlaid with the motifs made fashionable by city cabinetmakers, such as the eagles with shields, oval medallions, corner fans, and pendant bellflowers seen here. The eagle is one of the popular symbols of the new nation that permeated all the American decorative arts during the last quarter of the eighteenth century. (*Greenfield Village and Henry Ford Museum*)

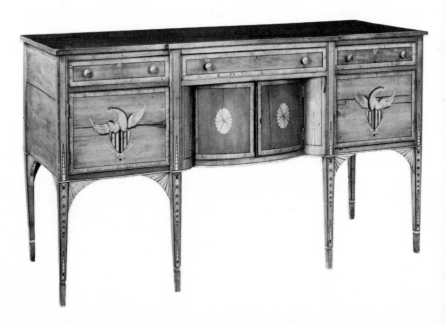

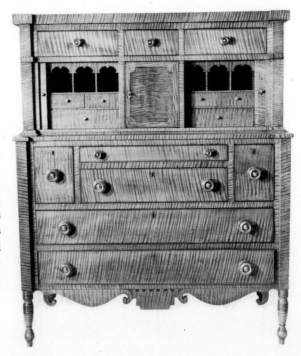

72. Sheraton tambour secretary. New Hampshire. c. 1825. Curly maple and cherry. H. 52″. Tambour sliding doors close over the banks of drawers and pigeonholes that flank the central door. Photograph courtesy Kenneth E. Tuttle. (*Private collection*)

wood, a wood that became very fashionable. Rosewood graining was done with precision and beauty by fine cabinetmakers, but in the country imagination took command and with these colors produced the bold effects seen in plate 27 and especially in figure 78. This latter piece, a blanket chest-on-chest of drawers, was made in Maine in the 1830s, and it appears to be unique both in its form and decoration. Whoever painted its enrichments obviously decided to "Let 'er rip!"

There are many more examples of the way in which imaginative painting has given a special touch to what would have been dull furniture if it had been left in the natural wood. The chest of drawers (plate 21) illustrates an enchanting rural version of the eighteenth-century rage for chinoiserie decoration in the Colonies. Its colorful pastoral delights, punctuated with vaguely Oriental

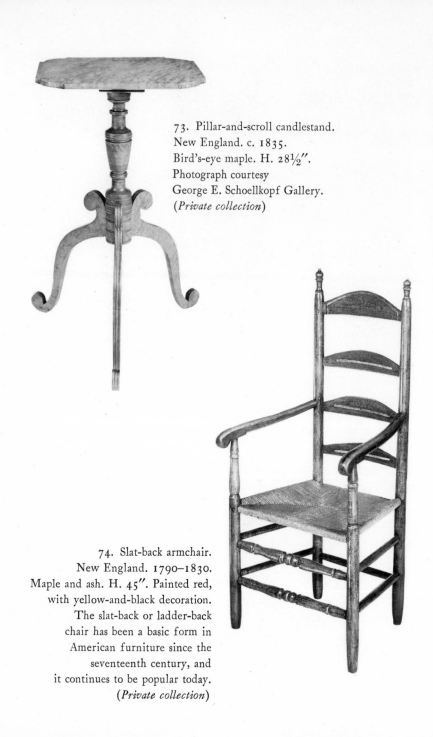

73. Pillar-and-scroll candlestand.
New England. c. 1835.
Bird's-eye maple. H. 28½".
Photograph courtesy
George E. Schoellkopf Gallery.
(*Private collection*)

74. Slat-back armchair.
New England. 1790–1830.
Maple and ash. H. 45". Painted red,
with yellow-and-black decoration.
The slat-back or ladder-back
chair has been a basic form in
American furniture since the
seventeenth century, and
it continues to be popular today.
(*Private collection*)

75. Looking glass. New England.
1825–1840. Pine. H. 22″.
Black paint with gilt stenciling.
Stenciled motifs were used on
all types of city and country
furniture during the period 1815–1840.
These designs decorated innumerable
chairs produced by Lambert Hitchcock
of Connecticut and his imitators,
and the "Hitchcock" chair remains
popular today. The rosettes in the
corners of the looking glass
simulate the brass mounts used on
city-made examples.
(*Old Sturbridge Village*)

buildings, represent a watering down of the exotic designs published with resounding success in England by John Stalker and George Parker in their "how-to-do-it" book called *A Treatise of Japaning and Varnishing* (1688). Figure 79 is a particularly handsome chest, most probably made in Vermont about 1825. The decoration on the front clearly has been inspired by the inlay work of city cabinetmakers. Then, having made a bow to his betters, our man in Vermont went all out on the top and sides of the chest to express his own design skills.

One of the most familiar and sought-after types of furniture today is the eighteenth-century Windsor chair, for in its many forms it has come to be identified with the American country style, despite

76. *Asa and Susanna Caverly*. Joseph H. Davis. Strafford, New Hampshire.
c. 1836. Watercolor on paper. 11″ × 14″. Inscribed: *Asa Caverly.*
Aged 24. October 5th 1836. Painted at Strafford / Bow Pond / August 9th / 1836.
Susanna Caverly. Aged 29. August 14th 1835. The painted table and
chairs are in the country Empire style. Note the idyllic scene hanging
above the table. (*Mr. and Mrs. Edwin Braman*)

the fact that in the eighteenth century Windsors were regularly
used in formal interiors. They were part of the furnishings at
Mount Vernon, and they are prominent in the famous painting of
the signing of the Declaration of Independence. Windsors were con-
structed of several types of wood, each type used because it best
served the specific purpose of the cabinetmaker. For instance, a
chair might have a pine seat because pine could be shaped and
carved with subtlety. The legs, spindles, and stretchers were often
turned from maple for strength. Beautifully shaped bow-backs

and handsome, curvaceous arms were made of willow, which was supple and easily bent. Each wood differed in color, consequently, the various woods would assume different colors, Windsors were almost always painted. The Commons Room at the Winterthur Museum (fig. 69) contains a triple bow-back Windsor settee. In front of it are two low-backs, at the left is a bow-back side chair, and at the rear near the staircase is a high-back armchair. Windsors were also made in many different styles in the nineteenth century, and they are differentiated today by such terms as "rod-back," "bird-cage," and "arrow-back." All these types were painted.

The slat-back chair, like the Windsor, was constructed from different kinds of wood; so it was nearly always painted. Figure 74 shows a typical late eighteenth- or early nineteenth-century example, where the basic coat of red has been enlivened with yellow-and-black stripes.

77. Box. Maine. 1830–1840.
Pine. W. 12⅜".
The seaweedlike designs have been executed in brown paint on a yellow background.
(*Private collection*)

Folk paintings provide invaluable visual information about typical country furnishings. In the wonderful 1836 watercolor portrait of Asa and Susanna Caverly of Strafford, New Hampshire (fig. 76), we see a table and chairs that are vigorously painted rural versions of the Empire style, which became fashionable in the major cities about 1815. In the same way, Deborah Goldsmith's watercolor of the Talcott family in upper New York State (plate 24) is treasured not only for the several portraits, but especially for its

78. Blanket chest-on-chest of drawers. Maine. 1830–1840. Pine. W. 39⅞″. The colors on this chest are black on a rust ground; the extraordinary decoration almost approaches modern Abstract Expressionism in its conception. (*Private collection*)

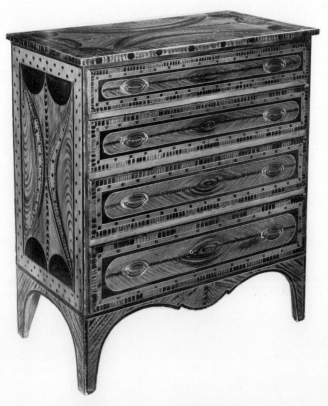

79. Chest of drawers. Attributed to Thomas Matteson, South Shaftsbury, Vermont. c. 1825. Maple. W. 37¼″. This is a particularly handsome creation in brown and ochre paint combining imitative graining on the front and imaginative designs on the top and sides. (*Mr. and Mrs. Ridgely W. Cook*)

careful depiction of the country interior: the painted and grained chest, the white-painted Windsors decorated with green sprigs (seen on the rocking chair at left), the diminutive Windsor footstool, and the home-loomed, striped carpet. Innumerable nineteenth-century portraits of the 1825–1840 period show the subjects sitting in similar painted "rabbit-ear" Windsors.

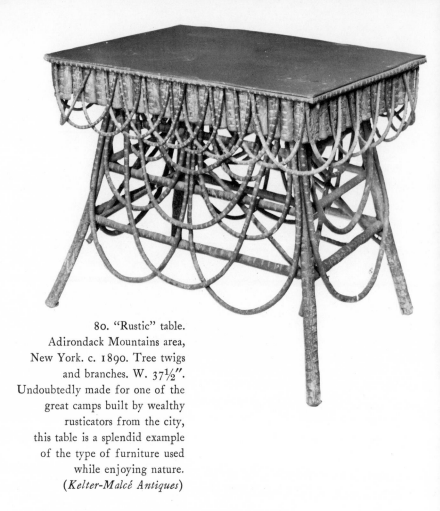

80. "Rustic" table.
Adirondack Mountains area,
New York. c. 1890. Tree twigs
and branches. W. 37½".
Undoubtedly made for one of the
great camps built by wealthy
rusticators from the city,
this table is a splendid example
of the type of furniture used
while enjoying nature.
(*Kelter-Malcé Antiques*)

Country painters were well used to performing a wide variety of jobs: those who decorated furniture with style and dash considered themselves fully up to rendering portraits as well. Thus the account book of the youthful Portsmouth, New Hampshire, artist John S. Blunt shows that he not only repaired chairs and decorated tinware for an apothecary, but he also did paintings of ships, seascapes, landscapes, and executed portraits in the very latest style.

In the middle of the nineteenth century A. J. Downing, who

was a fashionable tastemaker of the time, showed an appreciation for simple, handcrafted rusticity in his book titled *Cottage Residences* (1844): "Rustic seats placed here and there in the most inviting spots, will heighten the charm and enable us to enjoy at leisure the quiet beauty around." Later, in 1858, Downing illustrated in *The Horticulturist* several pieces of furniture made from tree roots and branches. Toward the end of the nineteenth century people of wealth made the trek to the Adirondack Mountains in New York State to "get back to basics" and "get in tune with Nature once again." There they established themselves in grandly "simple" camps, and a whole school of rustic furniture came into being, of which the table (fig. 80), with its elaborately looped and swagged tree branches decorated with notching, is a prime document.

As noted above, this brief account of the rich development of American country furniture has necessarily concentrated on the painted examples. It seems appropriate, therefore, to conclude with an excerpt from Nina Fletcher Little's foreword to *American Painted Furniture* by Dean Fales: "In our day of machine production hand craftsmanship of any kind is becoming increasingly rare. I find that my satisfaction in the warmth and subtlety of the old hand-mixed pigments does not diminish, nor does my conviction that in saving the old finishes, and recording them in print, we are preserving for the future a few significant scraps of America's fast-vanishing heritage of painted decoration."

FURTHER READING

BISHOP, ROBERT. *The American Chair 1640–1970*. New York: E. P. Dutton & Co., 1972.

————. *How to Know American Antique Furniture*. New York: Dutton Paperbacks, 1973.

COMSTOCK, HELEN. *American Furniture: Seventeenth, Eighteenth, and Nineteenth Century Styles.* New York: The Viking Press, 1962.

DE JONGE, ERIC, ed. *Country Things: From the Pages of The Magazine, Antiques.* New York: Weathervane Books, 1973.

FALES, DEAN A., JR. *American Painted Furniture 1660–1880.* New York: E. P. Dutton & Co., 1972.

———. *The Furniture of Historic Deerfield.* New York: E. P. Dutton & Co., 1976.

KETTELL, RUSSELL HAWES. *The Pine Furniture of Early New England.* Reprint. New York: Dover Publications, 1949.

KOVEL, RALPH M., and KOVEL, TERRY H. *American Country Furniture 1780–1875.* New York: Crown Publishers, 1965.

SCHWARTZ, MARVIN D. *Country Style.* Brooklyn, N.Y.: The Brooklyn Museum, 1956.

AMERICAN QUILTS

by

Jonathan Holstein

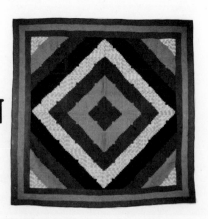

A quilt is simply a cloth sandwich: a top and a back with a filler in between, stitched through ("quilted") to hold the three layers together and to keep the filler in place. The precursor of the quilt was most likely a bag made of animal skin or cloth stuffed with some organic substance such as straw, grass, or feathers and used as a mattress or cover. The form survives in the "eiderdown" or "comforter" of Northern Europe and is commemorated in the word *quilt*, which comes from the Latin *culcita,* a stuffed sack. When such a bag was stitched or tied through to keep the filler evenly distributed, the first basic quilt was made.

There are records of quilts in Europe as early as the twelfth or thirteenth century, when what was unmistakably a patchwork-type quilt was described in a group of French love poems, "Les Lais del Desiré": "The bed was prepared of which the quilt was of a checkboard pattern of two sorts of silk cloth, well-made and rich." Except for a quilt of early fifteenth-century Sicilian manufacture, two pieces of which are in Italy and one in the Victoria and Albert Museum in London, no early European quilts have survived. The Sicilian quilt is made of plain coarse linen stuffed with wool, and it shows scenes from the story of Tristan and Isolde.

It is fairly certain that early European quilts were of three basic types. There were plain quilts of whole cloth, most likely of wool and linen for the populace. For the wealthy, more sumptuous materials were used, and they were decorated with quilted patterns. Then for show there were finely embroidered quilts. At some unknown date pieced and appliquéd quilts made their appearance. These two ancient decorative techniques, collectively called "patchwork," were applied to the tops of quilts, the part that usually carries the main decoration. In appliqué work, shapes are cut from one material and stitched to another. In *piecing* (the American term for this technique), pieces of material, usually precut in straight-sided geometric shapes, are sewn together edge-to-edge.

When the first English settlers arrived in the New World early in the seventeenth century they undoubtedly had quilts with them; and it is likely they also made them from the earliest days of settlement. Probably there were plain quilts and quilts made from salvaged materials pieced together. However, eighteenth-century examples are the earliest American quilts we have for study. These quilts are of three basic types: (1) plain quilts, usually of wool, with elaborate quilted patterns; (2) "show" quilts in several styles: one has been called a "framed center" or "central medallion" format, with a central square of some fine floral or scenic printed cotton set parallel to the edges of the quilt—or tipped to form a diamond—and surrounded by multiple borders, usually of a more ordinary cotton, with blocks in the corners, often of another fine figured material. Another type of show quilt had a plain white ground to which were applied, often in the same general arrangement as the framed center quilt, figures cut from chintzes. A third type of show quilt was composed all of pieced parts of fine cottons in one or more geometric shapes such as octagons or hexagons. The Star of Bethlehem (plate 28) was typical of the period, composed of diamond-shaped pieces fitted together in mosaic fashion to form an eight-pointed star which filled most of the top of the quilt. Frequently, such star quilts had smaller stars, or appliqués of cut chintz, within the points of the large star. These "show" or high-style quilts were very similar to those made in England during the same period. Even after the Revolution, many wealthy Americans looked to England for guidance in matters of culture, fashion, and decoration.

The third type of quilt was the utility quilt, the all-pieced quilts made of common, sturdy materials. The earliest ones found are made of linsey-woolsey, a fabric with linen warp and wool weft. It is unknown where these types originated, but the evidence so far suggests it was England. The earliest pieced cotton quilt

still in existence can be seen at Levens Hall, in Cumberland, England. Reliable family history dates it to the first decade of the eighteenth century. It was made of scraps of seventeenth-century Indian chintzes in a fullblown geometric piece style.

Early models of most objects made in the New World were close copies of European counterparts. Later the particular conditions, materials, and work methods developed in the new land affected and altered the objects so that they acquired a distinct American look. In quilts, this evolution occurred in the appliquéd and pieced types. American women developed the "block style" of quiltmaking, which evolved from a search for the most efficient way of making quilts. The harsh winters demanded warm bed clothing for survival, and quilts were quicker to make and more efficient as insulators than blankets that were woven from home-grown wool. Farm and settlement workdays were long and hard, there was little time to waste, and thrift in labor and materials was demanded. The piecing method answered the requirements of thrift, for pieced tops were made from the bits of material in the family scrapbag that were left over from family clothesmaking or salvaged from the good parts of worn-out garments. An efficient way of handling such scraps was to plan first an overall pattern using geometric forms with straight edges, since these were the easiest to sew. The forms were then cut and stitched together, a method of working that produced an ever larger top to handle as the task progressed.

A more efficient method was hinted at in the framed center, high-style quilts. Sometimes the inner borders were made of rows of repeated geometric pieced designs contained in squares or rectangles. This idea, either taken from such quilts or developed independently, was the basis of the block style. The block design, formed within a square and usually based on divisions of the square, was repeated in identical configuration a number of times to make the quilt top. Blocks were composed usually of a number of geomet-

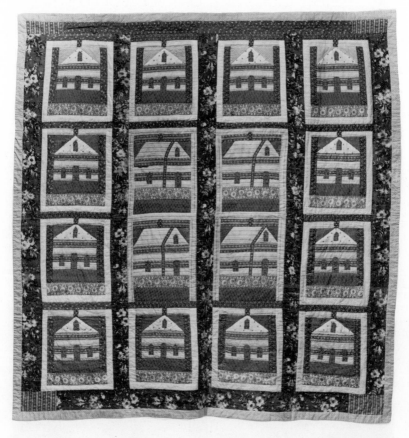

81. Schoolhouse. New Hampshire. c. 1870. Cotton. 77″ × 76″. This early and unusual interpretation shows two views of the schoolhouse; the side alone is the common block. (*Gail van der Hoof and Jonathan Holstein*)

ric shapes which fitted together to form the design. The shapes could be precut all at once, and the blocks assembled from a stock of "parts." Blocks were basically of two types: those meant to stand alone, and those meant to link. The first often were separated within the quilt by inner borders, sometimes called "sashes." The School House pattern (fig. 81) is a typical example. The second

were designed so that their parts would mesh with the parts of adjoining blocks to form a larger overall pattern that was difficult to envision from seeing only a single, isolated block. The Log Cabin (fig. 82) is a good representation of this type.

The block system had a number of advantages: it broke the

82. Log Cabin, Barn Raising design. Amish, Pennsylvania. c. 1870. Wool. 78″ × 77″. The use of patterned material is unusual. (*Gail van der Hoof and Jonathan Holstein*)

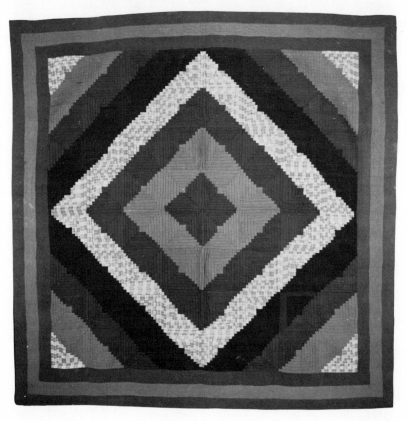

pieced surface into more manageable segments that could be lap-worked one by one as time permitted and stored away until enough were sewn to be assembled into a complete top. It was easier to assemble geometric shapes in squares and then put the squares to-gether than to make a fabric all in mosaic-style, each piece fitting to the next. A multitude of cutting and sewing imperfections could be contained, without harm to the overall pattern, within the squared sides of the blocks. And the block system's inherent potential for infinite design formulations offered broad possibilities for creative expression.

This last factor was by no means the least. There were few ways in rural America for women to express their creativity. For many generations quilts were perhaps the main outlet for the American woman's feeling for color, line, and form, and the quilts produced were often the brightest design in the rural home. Al-though such intricate sewing might seem tedious to people today, much testimony exists to the great pleasure women had in their quiltmaking; it was a relief from the considerable drudgery of the workday. The quiltmaker drew inspiration for her designs from the entire range of her experience and America's symbols: religion (Forbidden Fruit, World Without End, Circuit Rider), the thrusts and events of history (Road to California, Underground Railway, Nelson's Victory), politics (Lincoln's Platform, Old Tippecanoe), games (Johnny-'Round-the-Corner, Leap Frog), the joys and trib-ulations of life (Young Man's Fancy, Widow's Troubles), the natural world (Hunter's Star, Turkey Tracks, Pine Tree, Harvest Rose). The squared format of the block style furnished a frame-work for the geometricizing of images drawn from actual objects, or expressive of ideas. In the Courthouse Steps quilt (plate 29) for instance, the design was abstracted from the facades of public build-ings erected in nineteenth-century America in a style derived from classic Greek architecture. The block shows the columns, steps, and

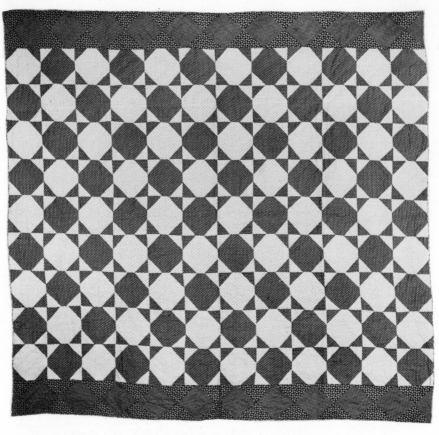

83. Robbing Peter to Pay Paul. Pennsylvania. c. 1880. Cotton. 77″ × 84″.
Scraps from the cutting of one block become part of the design elements of
the next block in this bold geometric form. (*Gail van der Hoof and
Jonathan Holstein*)

roof lines of such buildings. Robbing Peter to Pay Paul (fig. 83) was
a graphic representation of that notion. What was cut away from
a square piece of material to make the shape of one block became
the parts for its complementary block. Quiltmakers developed the
ability both to abstract actual images and to represent a wide range

of ideas through the use of geometric forms without specific references to actual objects. They learned how to evoke complex responses through visual manipulation of color and form. These were the great aesthetic triumphs of American quiltmakers; and in many ways the results were similar to the aesthetic solutions developed by modern abstract artists.

Both pieced and appliquéd quilts were made in the block style. Appliqué quilts were usually in floral patterns with many curved lines (plate 30). These were harder to sew than the straight lines of the pieced designs, and thus were exhibitions of needlework proficiency. Often appliqué quilts were considered better. There are also rare appliqué quilts with completely free-form designs, such as landscape scenes (fig. 84) with figures and action, or assemblages of natural or man-made objects.

The availability of cottons, the "palette" of the quiltmaker, influenced the development of quilt design. The first cottons to come to America were the Indian chintzes, which arrived in the seventeenth century and continued to be imported in the eighteenth. These Indian cottons, printed in exotic and colorful designs, were washable, colorfast, and sturdy though fine. They had been discovered by Europeans in the seventeenth century though they had existed since antiquity and were well known in other parts of the world. Far superior in design, color, and colorfastness to European printed textiles of the period, Indian cottons spurred the development of the English cotton weaving and printing industries, for which America eventually supplied the raw cotton. So efficient was England's production and so aggressive its marketing system that until well into the nineteenth century American cotton textile manufacturers could not successfully compete. For this reason, many American quilts of the first half of the nineteenth century were made wholly or in large part from English materials. These American quilts were in soft and muted tones, and integral to their de-

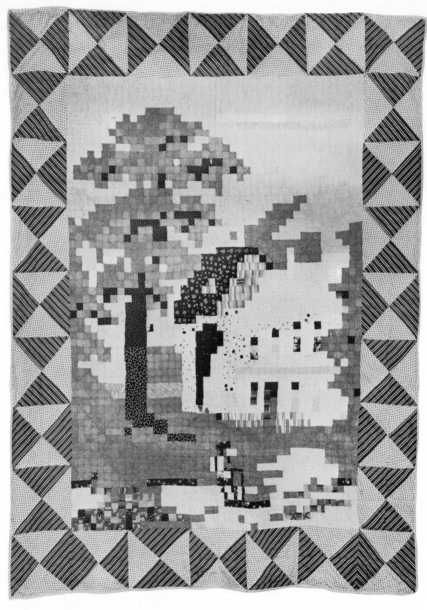

84. House in the Country. New England. c. 1890. Cotton. 75″ × 57½″.
Representational scenes in pieced work are rare. The quiltmaker used
small squares of color and pattern to indicate perspective, light, and
interior space. (*Gail van der Hoof and Jonathan Holstein*)

signs were the fine patterns such vegetable-dyed cottons displayed.

The mid-nineteenth-century development of chemical dyes brought many bright new colors to cotton fabrics. New printing methods increased the variety of patterns that could be made. Technological improvements in spinning and weaving equipment vastly increased the output of cotton cloth in both the United States and England, bringing prices down. The American woman of the latter part of the nineteenth century had a very broad range of colors and patterns from which to choose, at prices she could afford. This encouraged more design experimentation so that American quilts of the period were often visually the most inventive of all— the culmination of more than two centuries of experimentation.

Once the top was finished the quilt had to be assembled. This task could take longer than the making of the top. Quilts made for extra warmth, thickly stuffed with heavy materials on both top and bottom, were often tied through, or tufted, for it would have been difficult if not impossible to work them with fine quilting stitches. Most, however, were quilted. This was accomplished by the maker alone or with help from members of her family, or it might be done at a quilting bee.

Quilting bees were one of the main social institutions for women in nineteenth-century America. It was a time to visit, exchange gossip, and work productively together. Such communal work projects were common in early American life, and included barn raisings, husking bees, cooperative harvesting, and so forth. The woman at whose house the bee was to be held acted as hostess; often it was her quilt that was to be worked. She would clean house thoroughly, prepare some food, and set up the quilting frame. Neighbors would come, frequently bringing their cooking and baking specialties. The back of the quilt was stretched, the filler (earlier of wool, later of cotton) laid on, and the top stretched tightly over all. Quilting patterns were decided upon, and the appropriate lines

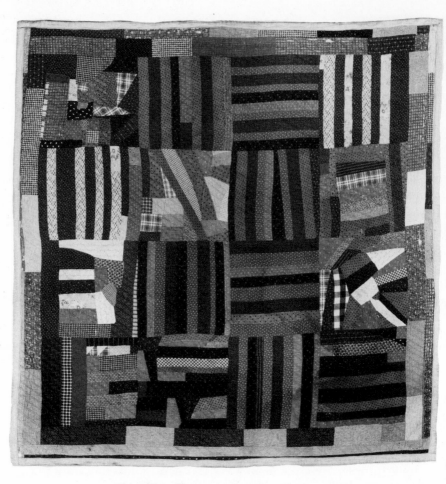

85 and 86. Two examples of crazy quilts. *Crazy* means "crazed"
in the sense of fractured or irregular segments. 85. Pennsylvania. c. 1865.
Cotton. 73″ × 73″. Strips and scraps organized into blocks with the
"crazy" motif carried along the border. 86. New England. c. 1920.
Cotton. 84″ × 84″. A modernistic design of cubes, triangles, and slivered
shapes. (*Gail van der Hoof and Jonathan Holstein*)

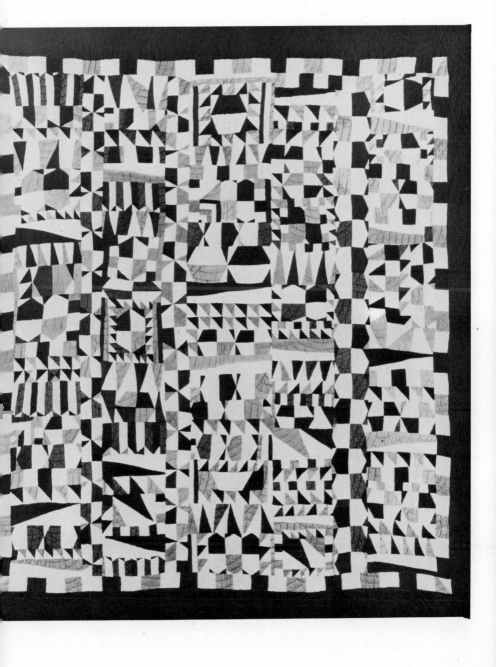

to form the designs were drawn on the top. These could range from simple parallel straight lines on a diagonal, which were the easiest to sew, to the very elaborate baroque patterns of feathers, wreaths, or flowers, with many curved lines to follow. The most expert quilters would take a place at the frame, while the less proficient would prepare food or thread needles for the sewers. The quilt was sometimes the bridal quilt of a betrothed girl, the top of which she had made of the best materials she could afford. In some parts of the country girls of marriageable age were expected to make twelve "utility" tops and one special bridal top, all to be quilted when she was betrothed.

In the evening, when the quilting was done, the men often came from their work for feasting, dancing, games, courting—all the festivities that were part of rural social life. Sometimes bees went on for days, with friends who had come long distances sleeping in the outbuildings or in their wagons.

Although such bees are of considerable interest in America's social and economic history, the work of the quiltmaker must be looked upon as individual creative effort. In the designs of her quilt tops, each woman had not only a multitude of traditional and ancient designs to consider but had also, in both pieced and appliqué work, the widest latitude for aesthetic choices. She chose a traditional design or invented one; she selected colors, textures, and patterns of cloth; she decided on the size and shape of the blocks and their individual parts; she chose the number, width, color, and pattern of both inner and outer borders. Obviously, women with superior aesthetic sensibilities produced the most visually interesting quilts (figs. 85 and 86).

An enormous number of quilts were made in America. As late as 1883, according to an article in *Arthur's Home Magazine,* a periodical of the time, three-quarters of the bed coverings in American homes were quilts. When one considers the size of the American

family at the time, remembering that each bed required a number of quilts and that new quilts were constantly being made as older ones were worn out, it becomes apparent that the number of quilts produced was staggering. Relatively few are left. The great appliquéd and pieced quilts that were considered masterpieces in their own time were often carefully preserved. The advent of more efficient home-heating systems did not immediately diminish a craft that was deeply rooted and much loved; and many quilts made late in the nineteenth century have come down to us little used or not at all. But both the best of quilts and the most utilitarian that were subjected to the bustle of rural life, washed and rewashed, eventually succumbed. None, so far as is known, survived the seventeenth century, a handful are left from the eighteenth and some from the early part of the nineteenth century. What we have is largely the product of the later nineteenth century. Fortunately, some of the most important quilt designs were produced in this period. Surviving quilts include those that were meant to be used as simple bedcovers, those with extraordinary quilting and minimal visual interest, those of great visual interest and—the rarest—those that combine both superb craftsmanship and important visual aspects. These masterworks can be either appliqué or pieced work; the former are more in the "folk image" tradition and the latter are based on externally valid and appealing geometric forms, exhibiting the visual toughness and intensity associated with the most lasting artifacts of any culture or time.

FURTHER READING

BISHOP, ROBERT. *New Discoveries in American Quilts*. New York: Dutton Paperbacks, 1975.

CARLISE, LILIAN BAKER. *Pieced Work and Appliqué Quilts at Shelburne Mu-*

seum. Museum Pamphlet Series, Number 2. Shelburne, Vt.: The Shelburne Museum, 1957.

COLBY, AVERIL. *Patchwork*. London: B. T. Batsford Ltd., Newton Centre, Mass.: Charles T. Branford Co., 1958.

————. *Quilting*. New York: Charles Scribner's Sons, 1971.

DENTON, WILLIAM BUSH, JR. *Old Quilts*. Maryland: privately printed, 1946.

FINLEY, RUTH. *Old Patchwork Quilts and the Women Who Made Them*. Newton Centre, Mass.: Charles T. Branford Co., 1971.

GUTCHEON, BETH. *The Perfect Patchwork Primer*. New York: David McKay Co., 1973.

HAKE, ELIZABETH. *English Quilting Old and New*. London: B. T. Batsford Ltd., 1937.

HALL, CARRIE A., and KRETSINGER, ROSE G. *The Romance of the Patchwork Quilt in America*. New York: Bonanza Books, 1935.

HINSON, DOLORES A. *Quilting Manual*. New York: Hearthside Press, 1966.

HOLSTEIN, JONATHAN. *The Pieced Quilt: An American Tradition*. Greenwich, Conn.: New York Graphic Society Ltd., 1973.

ICKIS, MARGUERITE. *The Standard Book of Quilt Making and Collecting*. New York: Dover Publications, 1959.

LAURY, JEAN RAY. *Quilts and Coverlets*. New York: Van Nostrand-Reinhold Co., 1970.

MIALL, AGNES M. *Patchwork Old and New*. Woman's Magazine Handbook No. 1. London: The Woman's Magazine Office, 1937.

ORLOFSKY, MYRON and PATSY. *Quilts in America*. New York: McGraw-Hill Book Co., 1974.

PETO, FLORENCE. *Historic Quilts*. New York: The American Historical Co., 1939.

————. *American Quilts and Coverlets*. New York: Chanticleer Press, 1949.

ROBERTSON, ELIZABETH WELLS. *American Quilts*. New York: The Studio Publications, 1948.

SAFFORD, CARLETON L., and BISHOP, ROBERT. *America's Quilts and Coverlets*. New York: E. P. Dutton & Co., 1972.

WHITE, MARGARET. *Quilts and Counterpanes in the Newark Museum*. Newark, N.J.: The Newark Museum, 1948.

WOOSTER, ANN-SARGENT. *Quiltmaking: The Modern Approach to a Traditional Craft*. New York: Drake Publishers, 1972.

PENNSYLVANIA
GERMAN
FOLK
ART

by

Frederick S. Weiser

The term *Pennsylvania German* may be said to describe a cultural component of North American population: immigrants and descendants of immigrants from Germanic Europe (areas today incorporated into the Federal Republic of Germany, France, and Switzerland), who arrived in America between 1683 and 1812 and settled initially and chiefly in Pennsylvania, but who soon moved into large areas of Maryland, Virginia, and North Carolina—and Ontario and Ohio—and ultimately contributed to the total composition of America's population in all the states. As a cultural group, these people retained many of their European life patterns, such as their religious beliefs, superstitions, customs, dialect, and their agricultural economy. At the same time, they borrowed from their non-Germanic neighbors so that much of their culture is no longer purely Germanic. This is no less true of their material culture—the things they owned—which is of great delight to the student of American naïve art because of the variety of forms they used and the generosity of the application of art motifs to it.

We shall take a rapid tour of the objects that might be considered part of Pennsylvania German folk art, with comments on how art is applied to them; and then we shall turn to the repertory of design we find and comment on its significance.

1. *Fraktur* is a twentieth-century term for all the folk art on paper of the Pennsylvania Germans. Essentially Fraktur is an illuminated text (plate 31). Among the minority sectarian groups (the so-called plain people—chiefly the Mennonites) the *Vorschrift* (penmanship example) was most popular; it contained a Scripture or hymn text or other admonition, or the alphabet in various forms, with embellished letters or drawings. Among the majority sects, Lutherans and Reformed, the *Taufschein* (baptismal certificate) was most prevalent; it contained the record of a person's birth and

baptism in a setting of hearts and flowers and birds and other decorations. A host of other forms—illuminated bookplates, book-markers, awards of merit, broadsides, hymnals, and even drawings —may be included in this category. Specialized cases of Fraktur are (a) the work done at the Anabaptist cloisters at Ephrata and Snow Hill from the 1740s to the 1850s, which attracted international attention in Colonial days; (b) examples produced in the tiny com-munity of Schwenkfelders, chiefly in upper Montgomery County among descendants of Silesian Protestant exiles who developed a style of their own; (c) the work of Lewis Miller at York forms a special class that is extremely important historically because it is a portrayal of daily life in a small south-central Pennsylvania Ger-man town; and (d) the folk portraits of Jacob Maentel (figs. 61 and 62) and others—still in need of comprehensive study—comprise a separate category as well. A good hundred separate hands can be recognized in Fraktur, and the names of many of the artists are known. Although many more must have been made, literally thou-sands of examples have survived, and the unexpected can and does emerge from an attic or family Bible even today in rural Pennsyl-vania. The original owners relished these papers chiefly for their text, which is most often of a religious nature. Since close European prototypes exist, carefully established criteria must be followed in determining what is Pennsylvania German in origin.

2. Iron implements, tools, and hardware surrendered easily to the decorative whim of the Pennsylvania German craftsman. There are door pulls with tulip forms, hinges with frog's legs, bird's heads, tulips, or hearts, Conestoga wagon parts in similar patterns; there are pancake turners and meat forks (fig. 87) adorned with inlaid brass and copper, or cutout stars and flowers and hearts, or chased similar motifs, also pie crimpers and dough scrapers. Heavier items such as stove plates, trivets, bootjacks (both wrought and cast),

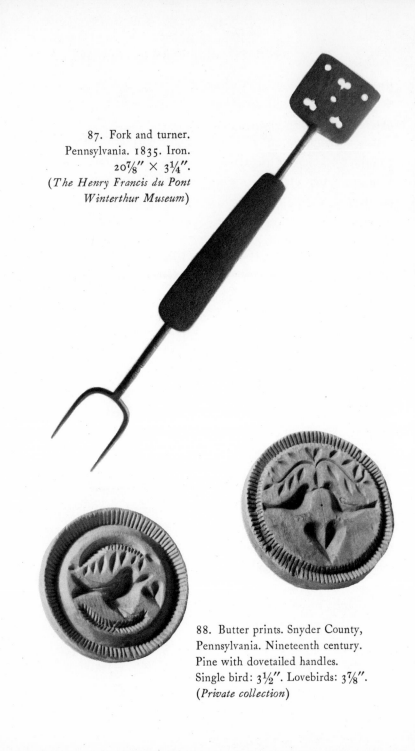

87. Fork and turner.
Pennsylvania. 1835. Iron.
20⅞″ × 3¼″.
(*The Henry Francis du Pont
Winterthur Museum*)

88. Butter prints. Snyder County,
Pennsylvania. Nineteenth century.
Pine with dovetailed handles.
Single bird: 3½″. Lovebirds: 3⅞″.
(*Private collection*)

trammels, waffle irons also exist in plain and decorated examples. Weathervanes of iron—later of other media—submitted to a variety of shapes, some heroic, some humorous.

3. Wood could be cut out as a slaw cutter, carved intaglio as a butter mold (fig. 88), sculpted as a bird, or cut and joined into furniture. It is not surprising to find a slaw cutter (fig. 89) or a flax hetchel (fig. 90) with cutout hearts in place of a simple hole for hanging, or the entire gamut of designs cut into a stamp for

89. Slaw cutter.
Pennsylvania German.
Nineteenth century.
Walnut. 17½″ × 6¹¹⁄₁₆″.
(*Private collection*)

90. Flax hetchel
mounted on wood board
with heart carving.
Early nineteenth century.
25″ × 6½″.
(*Moravian Museum*)

91. Painted trinket box.
Pennsylvania German. First quarter
of nineteenth century. Wood.
8¼″ × 5½″ × 3⅞″. (*Private collection*)

butter (although butter stamps were imported from the Continent, too). There are whittled birds—even a set of birds in a tree—and animals, representing the closest the Pennsylvania German came to creating art forms that had no practical task in their workaday world. The whole range of furniture decorated with paint and sometimes inlay began with the blanket chest, a personal piece of property that often bore its owner's name and the date, presumably, of acquisition. It included small trinket boxes (fig. 91), candle boxes, stools, chests, spice or salt boxes, dough trays, clocks, clothes cupboards, wheels and winders, chairs, and in the remote Mahantango Valley, even chests of drawers and kitchen cupboards.

4. Cloth lent itself to many uses. Heavy somber-toned woven coverlets were found in the trousseau of the Pennsylvania German girl from the time of the first settlement. Gaudily colored, appliqué (plate 32) or pieced quilts, chair cushion tops (fig. 92), and pillow slips (fig. 93) found their way into the Pennsylvania German folk culture from their English neighbors early in the nineteenth century. Samplers enjoyed limited popularity and the earliest were

92. Appliquéd chair cushion top.
Pennsylvania German. 1869.
Red, yellow, orange, and green
cotton appliquéd to a
printed cotton, bordered with
another print and backed
with a third. 16⅜″ × 15⅝″.
(*Private collection*)

93. Appliquéd pillow slip.
Inscribed Mary Ann Weaver.
1857. Tulip and rose wreath.
28″ × 17¼″. (*Private collection*)

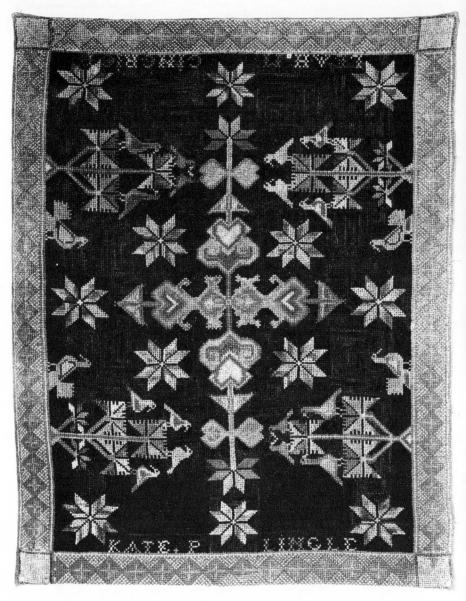

94. Rug. Probably Mennonite, Lebanon/Lancaster County border.
Late nineteenth century. Embroidered wool on homespun, with twin hearts,
turtledoves, and stars. 50″ × 39″. Signed "Leah M. Gingrich and
Kate P. Lingle." (*Private collection*)

95. Cookie cutters.
Pennsylvania German.
Nineteenth century. Tin.
Horse: 8³⁄₁₆″ × 8¹¹⁄₁₆″.
Lady's shoe: 7″ × 7″.
(*Private collection*)

often simply collections of designs that were used on the more popular hand towels ("show towels"), embroidered in cross stitch and occasionally chain stitch or in crewel. Some were appliquéd, although rarely, and sometimes further worked by drawing threads to form patterns. Bed linens were sometimes similarly prepared. Tablecloths, aprons, doilies, needle pockets, rugs (fig. 94), and other objects were sometimes embroidered, too. Hooked rugs were also borrowed from English neighbors and enjoyed limited popularity. The early Pennsylvania German household had neither rugs on the floors nor curtains at the windows.

5. Tin—easily worked—became a medium for kitchen utensils. Great coffeepots with punched designs, molds pierced for draining the egg cheese or cottage cheese the *Hausfraa* loved to make, and cutters in forms that defy enumeration, for rolled cookies (fig. 95) to enliven a child's Christmas; all were the tinsmith's delight. So, too, were sconces, chandeliers, and stencils for quilt patterns (fig. 96). "Tole"—tin objects colorfully painted—were popular in Pennsylvania; whether from Britain, New England, or local sources is

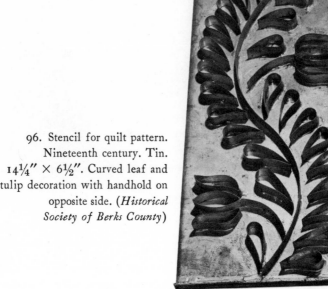

96. Stencil for quilt pattern. Nineteenth century. Tin. 14¼″ × 6½″. Curved leaf and tulip decoration with handhold on opposite side. (*Historical Society of Berks County*)

still a mystery. Decorated objects in pewter and copper are rare, although both metals were widely used.

6. Pottery was a functional necessity of the home, and in the earliest period country potters almost exclusively furnished the table. Day-to-day service was simple redware embellished by slip decoration, sometimes in two or three colors. Fancy presentation pieces—seldom, if ever, used—were further worked by sgraffito: a design, and frequently a motto, too, were cut through the slip before firing. Humor often turns up here, for instance, the German proverbs which translate, "Sooner would I single live than to my wife the britches give"; or, "I cook what I can cook still, what my pig won't eat, my husband will." Nineteenth-century British china manufacturers produced heavily for the Pennsylvania market in wares known today as "gaudy Dutch" or "spatter," and also in

figurines (fig. 97) that the local potters learned to emulate in the form of banks or whistles. Chalk figures, whose provenance is still unclear, were also quite popular at mid-nineteenth century.

7. A number of decorated powder horns survive, and now and again a horn fashioned with a hook to be worn on the belt, to hold the whetstone during harvest, also bears some design. Horn cups had small appeal. It is difficult to distinguish European examples from Pennsylvanian.

8. Glass was made and embellished in Pennsylvania and nearby, but few signed pieces exist and attribution is next to impossible, so common are forms and colors and decorations among various American and European glass houses.

9. The skills of a variety of media were combined in the hands of the gunsmith, whose precision instrument not infrequently was lavishly adorned on the stock and patchbox with silver and brass inlay. Misnamed the Kentucky rifle, the weapon had its beginning in Pennsylvania in the hands of the German settlers there.

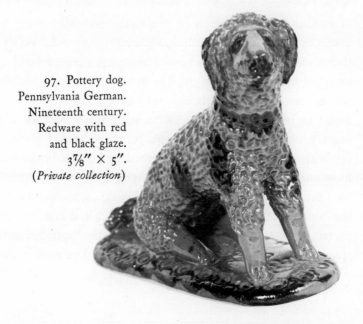

97. Pottery dog.
Pennsylvania German.
Nineteenth century.
Redware with red
and black glaze.
3⅞″ × 5″.
(*Private collection*)

10. Architecture may be more of a form of folk art than it is often credited. The central chimney, three-room floor plan comprising large kitchen, parlor, and master bedroom was the basic house style; it was far more prevalent than what meets the eye on a trip through Pennsylvania today. Georgian house styles began to influence Pennsylvania German tastes before 1800; many Germanic houses were remodeled, and others were built to conform to this style. The Pennsylvania German house developed the double front door, a regional architectural peculiarity born of the tension between the Georgian and Pennsylvania German architecture. The barns of the Pennsylvania Germans were varied. Many of the bottom barns, with stable-threshing floor/storage area-stable on one floor, have disappeared. The "bank barn," eventually prevailed. It had stables on the lower level opening into a courtyard, which was somewhat protected by a cantilevered overhang from the upper level. The upper level was the grain and wagon storage area and threshing floor (and could conveniently be opened to fodder the animals below) and was entered by a ramp on the opposite side. The host of smaller functional units on the farmstead—bake oven, smokehouse, corncrib, summer kitchen, and even privy—evolved styles of their own. Date stones with house blessings in stone or wood capped many of the larger buildings. The great painted stars and flowers on the barns, often misnamed hex signs, developed after barns began to be painted, in the nineteenth century. Cutout vents in heart, whirling teardrop, or tulip shapes are older. Decorative vents for brick barns were sometimes created by leaving bricks out; the most interesting is in Franklin County: a man on muleback.

11. At the end of life the tombstone, often decorated with the same motifs that graced the baptismal record and with similar poetry, crowned the grave. Not surprisingly the baptismal certificate frequently found its final home in the coffin. The earliest markers

were three-dimensional and baroque in style. Eventually simpler incision and reversion to folk motif becomes evident.

All of these objects are distinguished as folk art because they bear some decoration. They exist side by side with hosts of undecorated pieces in precisely the same forms. It cannot be stated too emphatically that their producers, purveyors, and original possessors did not regard them as art. We may readily say that so few of the artists' names are known because they did not regard their product as worthy of signature. Formal, academic art—easel painting, for instance—had little place among the Pennsylvania Germans; rather art embellished a functional object for the sheer delight in decoration. A modern analogy might be the decoration on cocktail napkins or toilet tissue. Mass-produced objects such as these fill a need in our lives and that is the reason they are made; the "art" on them is to make them nicer. The Pennsylvania German, even though he was a practical creature, had a love of life that spilled over into decoration. The forms of Christianity he confessed did not restrain that joyfulness, except perhaps among the Amish, and even there only in degree. An uninhibited—but not lewd—and healthy sensualism resulted. That is what Pennsylvania German folk art truly is.

The use of color—some of it probably garish when first applied —appealed to a largely workaday world. Color on buildings was so rare, for instance, that painted churches were often nicknamed by their colors: there were red, white, blue, and yellow churches in rural southeastern Pennsylvania. Trim in houses acquired a variety of hues in deliberate contrast to whitewashed walls. No wonder the blanket chest, *Taufschein*, and tole sometimes seem to scream with bright reds and yellows!

The most widespread characteristic of the use of design on

Pennsylvania German folk art is symmetry and balance. Motifs are generally found in pairs. Only a motif in the center of a piece will not be duplicated; but chances are good that it will be framed by two identical objects. This feature is at once one of the limitations of Pennsylvania German art and a clear reason for using the adjective *folk* in connection with it. It was easy for the untutored artist to accomplish with so little to do! There is abundant evidence that paper or cardboard or tin patterns were employed in creating Fraktur, blanket chest decor, cookie cutters, and quilts, for instance, and pattern books for coverlet and embroidery designs exist.

The motifs on the objects discussed may be simply listed. Most widespread are tulips, stars, flowers (sometimes to be distinguished from one another only by the beholder), vines, birds, hearts, the whirling swastika, teardrop, and angels. Among the less prevalent we find the mounted rider, the crown, the unicorn, other animals, and human beings. There are also extremely rare, almost exotic motifs, such as hunting scenes, wedding coaches, Adam and Eve, and as time rolls on, the eagle.

The question about the meaning of these motifs, if any, is closely tied with the matter of their source. Some theories have been advanced. Preston A. Barba, for instance, and others find them originating in prehistoric, pre-Christian Germanic mythology and design—a theory, by the way, that had widespread use in Nazi-era studies of German folk art. J. J. Stoudt asserts an origin in Christian pietistic imagery, as expressed otherwise in the hymns these people sang. The full preliminary study needed to answer satisfactorily the questions just posed has simply not been done. But, as yet, insufficient attention has been given to the related possibilities of simple copying of motifs and of a cultural decline. A few examples may suffice.

1. The *parroquet* (commonly called a parrot) once flew over

Pennsylvania in numbers and can be found freely interpreted on many of the art forms of the Pennsylvania Germans.

2. The widespread fascination with the *tulip* in Western Europe from the sixteenth century on is well documented. Its presence on Pennsylvania German objects may well come from its popularity at the time of production of these pieces.

3. The *unicorn* does exist on the British coat of arms, which is one possible source of the mythical beast on Pennsylvania German objects. But early Pennsylvanians also believed, as visitor in the 1750s Gottlieb Mittelberger tells us, that the unicorn lived in the remote forests of America.

4. The *crown* has ample text-related documentation on the *Taufschein*, as I have shown elsewhere; and when it occurs in the hands of a pair of angels on a tombstone, we have both obvious meaning *and* clear source in German baroque ecclesiastical art.

5. The heroic *man-on-a-steed* is widely found in German and other art forms.

6. The heart is a widespread device for the seat of human sentiment; when it occurs with the texts, "This heart of mine shall be all thine, oh dearest Jesus, Lord divine"; or, "Create in me a clean heart, Oh God," the general use of the motif is given specific application.

7. Specific pieces of Fraktur, such as Friedrich Krebs's drawings of the Seven Swabians or the Wedding Fable—and many of the printed broadsides, like the "Life and Age of Man," or the roads to heaven and hell—have clear European counterparts and prototypes. Some of the pottery and stove plates, and many of the sampler/show towel designs have too.

8. Printed material, such as baptismal certificates, from within the Pennsylvania German folk culture lent themselves as sources for designs on painted furniture, as the pieces made in the Mahantango Valley clearly illustrate.

When all of these sources are recorded, there is still room for playful imagination and creativity in the selection and arrangement of motifs. It is necessary really only to notice the relationship between the various objects—the borrowing, the adapting—to see one reason that the term *folk* is aptly applied to these things. The artists exercised their muse within the confines of generally accepted limits—limits imposed by the uneducated, unsophisticated, provincial, and informal tastes of the folks whose things these were. Thus the tulip may appear with more variety, in fact, than even nature endows it, but always we know that it is a tulip. And birds may have plumage that would scare a potential mate, but we know they are birds. So did artist and owner. As an art form, belonging to and springing from the community of Pennsylvania Germans, it may be one of the few that genuinely deserves the name *folk art* in American life.

The material below is a translation of the religious text in the Fraktur by Johann Adam Eyer seen in plate 31.

October 21 A.D. 1788

Barbara Landis

Give Jesus your heart in joy and in pain—in life and in death—this one thing is necessary.

Jesus, priceless treasure, take me totally to yourself, and put pure faith into my heart.

Let me surrender myself to your will that I may become forever your bride.

Light up in my heart the candle of love. I am yours my whole life through and forever.

I am part of you, your child and your dove. You are my head, my adornment and shelter in the rock. You alone are the vine, I one of the grapes, I continue to live in you even in the grave.

Depart all laments, looking to that day when we shall all live with you and meet you in the air.

Come dear Jesus, come and captivate me. My heart is overcome with laughter, since I see you there.

Oh, kiss me, dearest on my cheeks, let your good spirit take its place in my heart that I may sit at your feet, I want to kiss you, Jesus, dearest treasure, and then it's done. My heart clings only to yours, you are the desire of my soul and my passion, you bid despair depart and quiet all hurts. I am concerned for naught but your love.

Let me become comfortable in your arms. Dear Jesus, I already lie on your breast.

Oh, your breast is full of blessings which refresh us when death and hell press upon us and therefore you want to keep me at your side from which blood and water flowed. Through suffering let me pass on from this vale of tears to bliss.

> *Jesus, Jesus is my life*
> *He curbs all suffering*
> *He will give me strength of heart and cheer*
> *His name will I sing forever and ever*
> *Since Jesus lives in me.*

IAE SD

FURTHER READING

BARBA, PRESTON A. *Pennsylvania German Tombstones, A Study in Folk Art.* Allentown, Pa.: Pennsylvania German Folklore Society, 1953.

BORNEMAN, HENRY S. *Pennsylvania German Illuminated Manuscripts.* New York: Dover Publications, 1973.

GLASSIE, HENRY. *Pattern in the Material Folk Culture of the Eastern United States.* Philadelphia: University of Pennsylvania Press, 1968.

LICHTEN, FRANCES. *Folk Art of Rural Pennsylvania.* New York: Charles Scribner's Sons, 1946.

SHELLEY, DONALD A. *The Fraktur-Writings or Illuminated Manuscripts of the*

Pennsylvania Germans. Allentown, Pa.: Pennsylvania German Folklore Society, 1961.

STOUDT, JOHN JOSEPH. *Pennsylvania German Folk Art.* Allentown, Pa.: Pennsylvania German Folklore Society, 1966.

WEISER, FREDERICK S. *Fraktur.* Ephrata, Pa.: Science Press, 1973.

AMERICAN FOLK SCULPTURE

by
Frederick Fried

CIGAR-STORE INDIANS, SHOW FIGURES, AND CIRCUS CARVINGS

American folk sculpture existed as a vigorous and vital form of native art more than a hundred years before America's first native formal sculptor was born. But it was not until the 1930s that folk sculpture, like folk painting, was discovered as a true expression of the American people. The sculpture of self-taught folk carvers, who worked mainly in wood, reflected their environment with uninhibited vitality, originality of conception, and economy of materials. It was in striking contrast to the formal sculpture created by nineteenth-century Americans who studied in Europe and who were influenced by neoclassical traditions.

Unlike Europe, America had no extensive art traditions. Most of the early Colonists were men of humble background who were ignorant of the arts. Their strong religious prejudices and Puritan traditions forbade sculpture, which was considered the work of the devil, since the making of graven images was forbidden by Scripture.

Folk sculpture was first manifested on tombstones in the seventeenth century by simple incisings in two dimensions, which were the work of untrained slaters and stoneworkers. As the Colonies developed and expanded Puritan restrictions relaxed, and carved figural work began to appear on inn and shop signs. By the beginning of the eighteenth century, with the development of shipyards along the eastern seaboard, the specialized trades of shipwright, ship smith, and ship carver were flourishing. The bows and sterns of vessels were decorated with carved work. By the middle of the eighteenth century the Skillin family of ship carvers, located at Boston harbor, was known throughout the maritime trade for excel-

lent work (fig. 1). Other ship-carving shops were established from the Penobscot River in Maine to Charleston Harbor in South Carolina.

After the Revolution when the United States government ordered the building of a naval fleet, the commission to design the figureheads for six frigates was given to William Rush of Philadelphia, the leading carver of his time. Rush carved four of the figureheads, assigning the other two to fellow carvers. Rush was also renowned for carved cigar-store Indians and many figures for the Philadelphia Waterworks Commission (fig. 98). He made figureheads and tobacconists' figures until 1830.

The cigar-store Indian, one of the most picturesque and colorful of American trade signs, could be found on the streets of all the major cities, towns, and villages of the United States. In 1892, *Tobacco*, a trade publication, estimated their numbers to be in the tens of thousands. Today the wooden Indian is a rarity, found principally in museums and private collections.

This popular sign had its origin in England during the reign of James I. In 1588, Sir Richard Baker's *Chronicles* noted, "They returned homewards, passing by Virginia, a colony which Sir Walter Raleigh had there planted, from whence Drake brings home with him Walter Lane, who was the first that brought tobacco into England, which the Indians take against the crudities of the stomach." Various English histories of signs and signboards list many instances of early tobacconists' signs. Brathwait's *Smoking Age*, published in London in 1617, carried the first illustration of a tobacconist's sign, a small figure depicting the then current conception of an American Indian smoking a cornucopian pipe. The American Indian was represented as a Negro wearing a kilt and headdress of feathers, holding a smoking pipe in one hand and a roll of tobacco under his arm. Carved in wood and stained black,

98. *Nymph and Bittern.*
William Rush. 1809. Wood.
H. 91″. This is the wooden
original that Rush carved
for a fountain in Philadephia.
In 1854 the sculpture
was cast in bronze.
(*Fairmount Park Commission*)

this type of figure became known as "Virginians" or "Black Boys." In the seventeenth and eighteenth centuries they were found all over England and the Continent.

The tobacconist's figure was introduced in America in the eighteeenth century. The American Indian as a tobacconist's sign (fig. 99) was used in the beginning of the nineteenth century and it is probable that its application dates much earlier. A watercolor drawing (fig. 100) by the Baroness Hyde de Neuville showing Greenwich Street intersecting with Dey Street in New York City in 1810 has a wooden Indian as a sign in front of a tobacconist's

99. Chief Black Horse. c. 1856. Wood, painted. H. 68″. There was a Chief Black Horse (1776–1838) who commanded the Fox/Saux tribes in the 1832 war named after him. This figure was carved in New York City for the Swiss Consul in Louisville, Kentucky. A tobacconist in Louisville later acquired the figure, and it stood in front of his tobacco shop for almost 70 years. (*Heritage Plantation of Sandwich, Massachusetts*)

shop. An advertisement in the *Albany Gazette & Daily Advertiser* of November 10, 1817, shows an Indian representing the tobacco wares of Caldwell & Solomons of that city. That particular Indian carved in pine has survived and can be seen in the Albany Institute of Art. Tobacconist's and other trade figures (fig. 101) were made in small towns along the eastern seaboard of the United States,

100. *Corner of Greenwich Street*. Baroness Hyde de Neuville. January 1810. Watercolor. 6½″ × 12½″. A small tobacconist's Indian stands at the left of the entrance to the second building on the right. (*The I. N. Phelps Stokes Collection of American Historical Prints, Prints Division, The New York Public Library*)

and those that survive are regarded as prime examples of American folk art.

John L. Cromwell, who was born in Massachusetts in 1805, served his apprenticeship as a ship carver before coming to New York in 1831 to establish a carving shop at 170 Cherry Street near the shipbuilding yards. Cromwell developed a reputation for carv-

ing Indian figureheads for ships that kept his shop busy supplying the rapidly growing maritime industry. During the 1840s, Cromwell trained a very talented apprentice, Thomas V. Brooks, who at nineteen years of age in 1847 opened his own shop at 260 South Street. Brooks later became the largest supplier of cigar-store figures

101. Detail of a painting by Jurgen Frederick Huge (1809–1878). Connecticut. 1876. Note the trade figures carved to look like Chinese that stand to the left and right of the entrance to the New England Tea Store, which was housed in the Burroughs Building at the corner of John and Main streets in Bridgeport. (*Bridgeport Public Library*)

in the country. A Brooks advertisement states: "From 75 to 100 figures always on hand."

Brooks's shop, composed of two apprentices and two assistants, turned out Turks, Sultans, Sultanas, Punches, Goddesses of Liberty, and milliners, tailors, furriers, and all types of trade signs categorically called "show figures." They were carved and painted by the hands of the master, journeymen, and apprentices, none of whom had been trained in the classical tradition; thus the figures retained a primitiveness and innocence reflecting the lack of formal study. In such a shop the master usually put his creative force into modeling the features, stance, and garments, after his staff had done the initial preparation. The distinctiveness of the figures that have survived attests to the innate talent of a master such as Brooks. Most figures were cut from a single spar, the arms were carved separately and joined to the body.

In 1869, by means of a new process for casting zinc developed by M. Selig of Brooklyn, a cigar-store Indian of metal was introduced by William Demuth. In the next ten years a large variety of figures—Indians, squaws, Pucks, Punches (fig. 102), Africans (fig. 103), Turks, pages, cavaliers—were cast in metal. These were more expensive than wooden figures because they involved models, molds, and castings; and although they could be left out in all kinds of weather, if they were knocked over they would break.

Wood carvings continued to be in demand, and in 1876 Samuel A. Robb opened a shop at 195 Canal Street, which was patronized by P. T. Barnum and other great circus impresarios who ordered carvings for their traveling shows from him. Robb's shop was the largest in the city and turned out show figures of all types. He made baseball players (fig. 104) with a sturdy stance and feeling of vitality that conveyed action; his clowns (plate 33) were comical, his Sultanas regal.

In other cities, notably Baltimore, Washington, Detroit, Phila-

103. Caffir Smoker. Cast-zinc figure No. 69 as illustrated in the 1872 catalogue of Wm. Demuth & Co. Photograph courtesy Frederick Fried.

104. *Baseball Player.*
Samuel A. Robb. New York City.
1888–1903. Wood, painted.
H. 58″. (*Heritage Plantation of Sandwich, Massachusetts*)

102. Tobacco shop of Hamlet Edwin Forrest in Hotel Pacific, New York. c. 1890.
Punch was a popular tobacconist's figure. Photograph courtesy Frederick Fried Archives.

delphia, and Montreal, ship carvers applied themselves to the carving of show figures and tobacconists' Indians to supply the trade. Research has turned up a long list of men active in this field. None considered himself a sculptor except Julius Caesar Melchers (fig. 9) of Detroit. City directories listed craftsmen simply as "Show Figure Carvers." Melchers, one of Detroit's most illustrious artists, also carved tobacconists' figures in his shop on Randolph Street. In an interview printed in the Detroit *News Tribune*, July 23, 1899, Melchers said: "When I came to Detroit in 1852 a few rudely carved and badly painted signs were found at the stores. The first work I did in Detroit was to carve a little Indian chief. I hired an Indian to put on a lot of savage finery and pose as a model. When I got the image done I received $55 for it and spent the money on a boat and gun and went exploring . . ."

Because of the competition from Samuel A. Robb, his former apprentice Thomas V. Brooks moved from New York to Chicago in 1879 taking along three carvers to start the New York–Chicago Carving Company. When Brooks arrived in Chicago he found Indians and show figures of recent make, some that had survived the great fire. Thomas Brooks, his son James, and his assistant Isaac Lewin provided Chicago and other cities and towns in the expanding west with cigar-store Indians and a variety of show figures. In New York, Brooks had been the carver for various circuses and had created the flamboyant carvings for the Van Amburgh wagons produced in the Fielding Brothers' shop. When Brooks went to Chicago most of the circus carving work was then given to Robb, who from 1882 to 1903 created a vast number of carvings for Barnum, Bailey and Hutchinson's wagons, and for Adam Forepaugh, and Pawnee Bill (fig. 105).

In 1902 James A. Bailey of the Barnum & Bailey Circus contracted with the Sebastian Wagon Company of New York for the construction of thirteen circus wagons to celebrate the circus's return

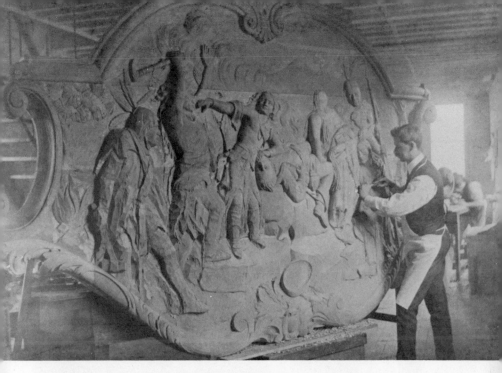

105. This old photograph shows a side panel from one of Pawnee Bill's Wild West Show parade wagons being carved in the Samuel Robb shop at the Sebastian Wagon Company. New York. 1902. The panel shows the famous scene of Pocahontas saving the life of Captain John Smith. Photograph courtesy Frederick Fried Archives.

to America after its five-year European tour. Bailey specified that Robb was to do all the carving. For the grand homecoming and opening at Madison Square Garden where the new wagons would be paraded, the program booklet *Realm of Marvels* noted ". . . the wood carving is easily the finest that has ever been executed in America, and as an entirety it has never been excelled, if equaled anywhere in the world. This carving was done in the mammoth atelier of Mr. S. A. Robb and required the combined efforts for more than one year of some twenty-five of the very best leaders of the wood-carving craft in this country."

These were the last circus wagons carved by Robb. After the

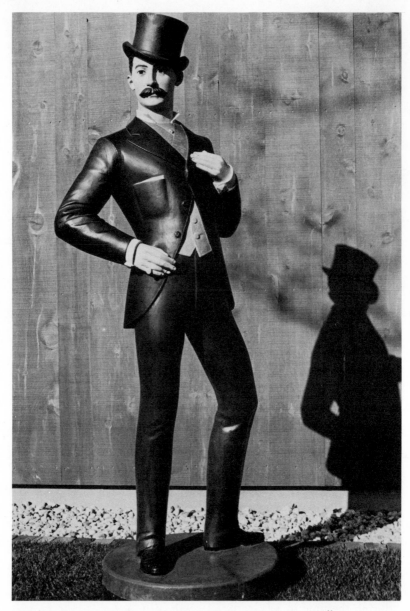

106. San Francisco dandy. 1880–1890. Wood, painted. H. 74¼″.
This probably was a shop figure for a haberdashery. From 1901 to 1969
it stood in Cliff House at Sutro Baths, San Francisco, a popular
resort. Photograph courtesy Frederick Fried Archives.
(*Heritage Plantation of Sandwich, Massachusetts.*)

introduction of electricity, electric signs replaced many of the painted and carved signs, and there were rulings in many cities and towns that outlawed tobacconists' Indians and other shop figures (fig. 106) as sidewalk encumbrances. The need for wood carvings came to an end. Nevertheless, many were still to be found in various cities and towns until the mid-1930s. Most of these were purchased from their owners by museums, collectors, and antiques dealers, once they became aware of their special appeal, their role as American folk art, and their scarcity. Today hardly one is to be found that serves the purpose for which it was created.

WEATHERVANES

Weathervanes, like cigar-store figures, were not indigenous to America. Nevertheless the adoption, use, and spirited variety of weathervane design in America surpassed that of any other country. It is this exuberant excellence that has attracted the attention of museums in recent years.

The weathervane, once an essential and important device for forecasting weather has been replaced today by scientists using instruments that depend upon air waves rather than winds. Except in rare cases, the vane has become a status symbol rather than a forecaster. But at one time the farmer, fisherman, and city dweller depended upon it when planning to make hay, cast nets for the catch, or prepare for storm.

The earliest recorded weathervane appears in the *Chronicles* telling of the *Tower of Winds* built in 100 B.C. by Andronicus. He crowned it with a bronze Triton that pointed a wand in the direction of the wind. Records report the use of weathervanes in England during the time of William the Conqueror. And after the French Revolution weathervanes were common in Europe. Gilded weathercocks appeared in European churches; legend has it that this was a

107. Grasshopper weathervane. c. 1900. Copper. H. 8¼″, W. 42″.
From a Cape Cod home. (*Heritage Plantation of Sandwich, Massachusetts*)

reminder of the cock that crowed the night Peter denied the Lord.

In America the first known weathervane was made in 1656 in Europe—a copper cockerel for the Dutch Reformed Church in Albany. Perhaps the best known is the hammered-copper grasshopper with green glass eyes made in 1742 in the Ann Street shop for the cupola of Faneuil Hall in Boston. It is still in use today. Its creator, Shem Drowne, born in Kittery, Maine, has been called America's first maker of vanes.

Early vanes were made of wood, pewter, sheet metal, tin, and hammered copper (fig. 107). During the eighteenth and nineteenth centuries vanes were made by farmers, carpenters, fishermen (fig. 108), and blacksmiths (fig. 109), who often employed themes related to their work. These reflected their views and the influences of their environment. The choice of designs was influenced by the artisan's religious ideas and sense of humor, as well as his limited ability, and these factors also affected the simple, bold execution of the cows, sheep, hogs, horses, and fowl used for vanes on barns, stables, and farmhouses. Codfish, whales, mermaids, and ships (fig. 110) were the design choices of sailors. In eighteenth-century towns and cities, vanes appeared mainly on churches and official buildings. It was not until the middle of the nineteenth century,

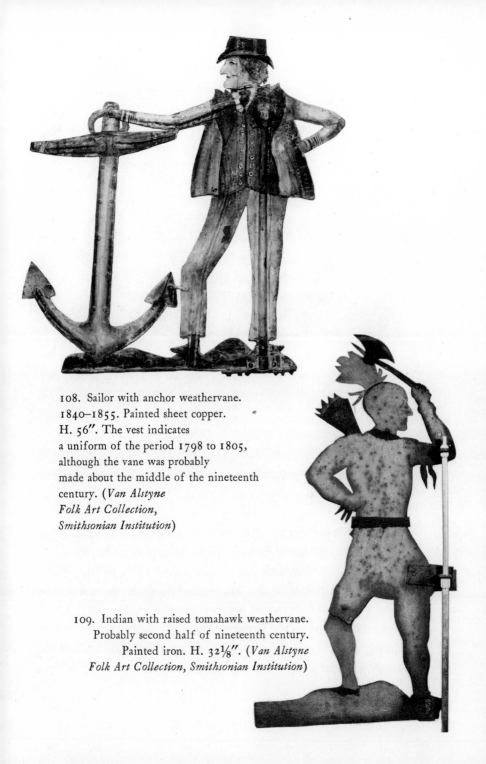

108. Sailor with anchor weathervane.
1840–1855. Painted sheet copper.
H. 56″. The vest indicates
a uniform of the period 1798 to 1805,
although the vane was probably
made about the middle of the nineteenth
century. (*Van Alstyne*
Folk Art Collection,
Smithsonian Institution)

109. Indian with raised tomahawk weathervane.
Probably second half of nineteenth century.
Painted iron. H. 32⅛″. (*Van Alstyne*
Folk Art Collection, Smithsonian Institution)

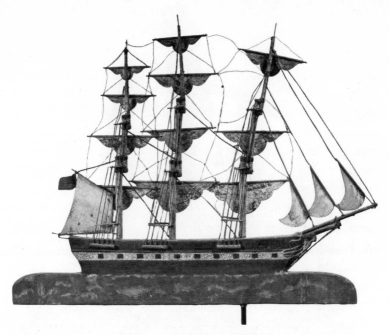

110. Square-rigged ship weathervane. Mid-nineteenth century. Painted iron. L. 40″. It is thought that the squares in the hull represent gunports, and this is a vessel of the era 1815 to 1850. (*Van Alstyne Folk Art Collection, Smithsonian Institution*)

with the increase in population and the industrial revolution, that factory-made weathervanes came into use.

The first factory was that of A. L. Jewell and Company of Waltham, Massachusetts. Its one-sheet catalogue issued in 1860 contained illustrations of farm animals, an eagle, arrow, a centaur (fig. 111), Columbia with her flag, a locomotive, trotting horse with sulky and driver, and a banneret. The vanes were made by placing a sheet of thin copper in a precarved or cast mold and then beating the copper to the pattern. The parts were then joined by soldering and the whole form was set on a spire with a set of the points of the compass, sometimes combined with an arrow or brass ball.

In 1879 seven firms were making weathervanes to order in any size or pattern. One set of order books lists eagles, Indians, and other vanes that were sent to Texas, California, and other remote areas of the country. Most of the firms were in New York and Massachusetts. In 1893, J. W. Fiske of New York issued a 140-page catalogue illustrating a great variety of subjects and designs for their weathervanes. After 1890, firms making vanes appeared in Pennsylvania, Ohio, Missouri, Illinois, and other parts of the country. Some stamped their names on their vanes or on the spire joints; most firms did not, making identification a task for researchers. Vanes of the more primitive kind made by blacksmiths, farmers, sailors, etc., are rarer and greatly sought after by museums and collectors. Both individually made and factory-made weathervanes

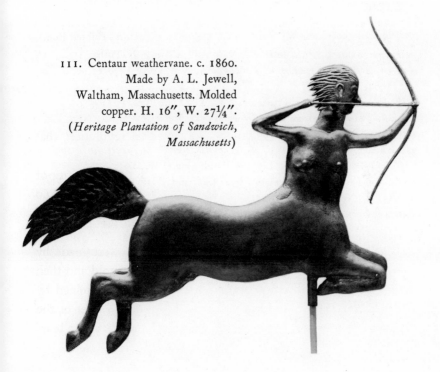

111. Centaur weathervane. c. 1860. Made by A. L. Jewell, Waltham, Massachusetts. Molded copper. H. 16″, W. 27¼″. (*Heritage Plantation of Sandwich, Massachusetts*)

are highly prized as a form of American folk art. As a consequence, theft of weathervanes is increasing as is the quantity of copies and fakes.

Like cigar-store figures, which were once tagged "artist unknown," weathervanes are now being identified by maker, date, and provenance with research. A few contemporary firms are making weathervanes. J. W. Fiske still makes vanes on order from old patterns. But the thousands that once dotted the skyscape have now given way to television antennae.

FURTHER READING

BISHOP, ROBERT. *American Folk Sculpture*. New York: E. P. Dutton & Co., 1974.

FITZGERALD, KEN. *Weathervanes and Whirligigs*. New York: Clarkson N. Potter, 1967.

FRIED, FREDERICK. *Artists in Wood*. New York: Clarkson N. Potter, 1970.

———. *A Pictorial History of the Carousel*. New York: A. S. Barnes & Co., 1964.

J. W. Fiske Catalog 1893. Princeton, N.J.: The Pyne Press, 1971.

LIPMAN, JEAN. *American Folk Art in Wood, Metal and Stone*. New York: Dover Publications, 1972.

PENDERGAST, A. W., and WARE, W. PORTER. *Cigar Store Figures in American Folk Art*. Chicago: The Lightner Publishing Corp., 1953.

PINCKNEY, PAULINE A. *American Figureheads and Their Carvers*. New York: W. W. Norton & Co., 1940.

SANBORN, KATE. *Hunting Indians in a Taxi-Cab*. Boston: Gorham Press, 1911.

AMERICAN
FOLK
ART
IN
THE
TWENTIETH
CENTURY

by

M. J. Gladstone

American folk art has been celebrated as a creative expression of the emerging society of the nineteenth century, but its recognition as art and the idea of American folk art as a special and separate artistic grouping are recent developments. Starting with the Impressionists if not earlier, we can chart the course of art as a series of "revolutions" that call attention to new, or at least temporarily obscured visual truths. The Impressionist revolution reexamined light and form, another artistic movement championed mundane life, and still others dwelt on the symbols of inner visions and proclaimed the unimportance of identifiable subject matter.

The emergence of American folk art as an idea is, in reality, one of these visual revolutions of the twentieth century, calling attention to a range of creative expression that hitherto had gone unnoticed. It differs from the others in that the artists whose works it recognizes seldom speak very cogently for their point of view and, in fact, have usually failed to speak at all. Folk art as an idea is essentially the creation of *non*practitioners (which is why the borderline between folk art and "found" art may sometimes seem rather thin).

The initial definers of American folk art were highly sophisticated scholars and museum people (Holger Cahill foremost among them), as well as art and antiques dealers, collectors, and—perhaps most important of all—artists who, like Kuniyoshi and Elie Nadelman, made use in their own work of the folk forms they championed. The vision they spoke for was highlighted by the work of the itinerant limners who had recorded the appearance of America's first settlers and its rising middle class, and by a variety of loosely defined "utilitarian" objects like trade signs, weathervanes, and decoys. In these, and in the work of later self-taught or so-called naïve painters and carvers, they found real pictorial or sculptural significance. They also focused attention on traditional crafts like pieced and appliqué quilts and rug hooking, on a vanished seminary

curriculum that gave rise to theorem work and pinprick drawings, and on regional expressions like the Fraktur of Pennsylvania and the *santos* and *bultos* of the Southwest.

Although awareness of American craft traditions had begun to develop at the turn of the century and interest in some of these other "nonart" forms can be discerned throughout the 1920s, it was only in the 1930s that all the major threads of American folk art were bound together in official action. Significantly, it was an exhibition organized by The Museum of Modern Art in 1932 that first focused widespread attention on historical aspects of the subject; and six years later, in 1938, it was The Museum of Modern Art's "Masters of Popular Painting" exhibition that placed the work of self-taught Americans in the context of contemporary international "naïve" art. The great efforts to record a vanishing America by the Index of American Design (fig. 112) and the Farm Security Administration photographic file were more specific expressions of the 1930s. The first was a Depression project to employ idle artists, and both concentrated on the true face of America, with the fashionable cosmetics of worldly affluence stripped away.

Broad recognition of American folk art came much later, but the original vision of the 1930s persists. In the years that followed, the Abby Aldrich Rockefeller Collection at The Museum of Modern Art was transferred to Colonial Williamsburg in Virginia; and this in turn, pointed the way for later restoration efforts to re-create the substance of simple daily life such as at Sturbridge, Massachusetts; Shelburne, Vermont; and Dearborn, Michigan. A major study and training center was developed at the New York State Historical Association in Cooperstown, New York, and in New York City the Museum of American Folk Art was created for the collection and exhibition of folk art alone. Research and comparison in the 1950s and 1960s uncovered lost facts that refined the vision, but the folk art canon, as it was defined at The Museum of Modern

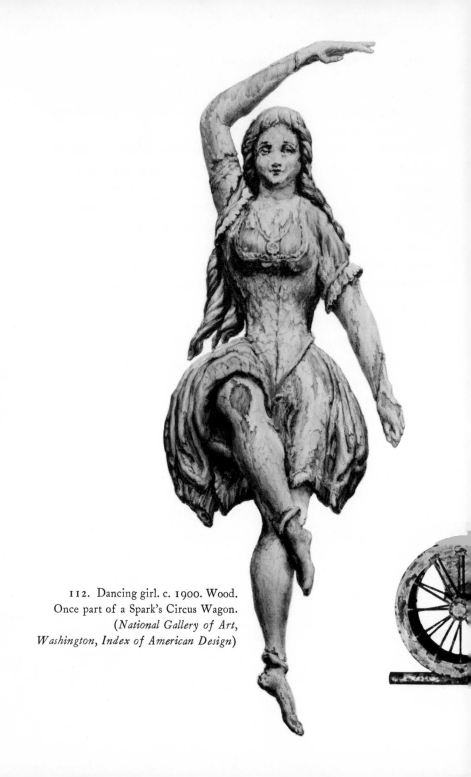

112. Dancing girl. c. 1900. Wood.
Once part of a Spark's Circus Wagon.
(*National Gallery of Art,*
Washington, Index of American Design)

Art and in the two great national archives, still seems to accommodate all the forms of expression that have been noted as folk forms.

Many of the modes of expression first identified as folk forms have been extinguished by technological advances. Illuminated birth and marriage records are no longer common, portraits have been largely supplanted by photographs, ships no longer sport figureheads, and becalmed sailors no longer make scrimshaw carvings. But much of what were first seen as American folk art's historic modes of expression continued to flourish after the nineteenth century. Traditional quilts and hooked rugs were produced in abundance during the Depression years and are still being made expertly today. Twentieth-century weathervanes depict automobiles (fig. 113) and airplanes with some of the inventiveness that went into earlier renditions of horses and angels. Machine-age whirligigs of enormous complication seem to be inspired by Rube Goldberg's

113. Car weathervane. c. 1907.
Copper. L. 42″, H. 21¼″.
(*Greenfield Village and
Henry Ford Museum*)

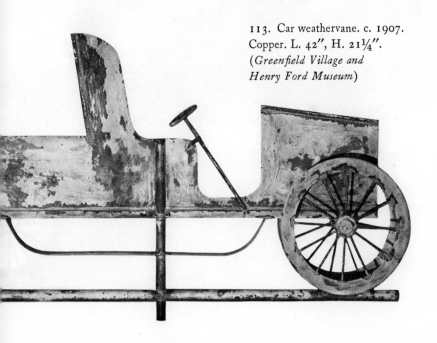

cartoons. Tattoo artists incorporate post–World War I armament into designs of mermaids, hearts, and flowers. Jewish and Italian gravestones continue to be worked with a variety of traditional low-relief symbols. The twentieth-century circus wagon (fig. 114) has been identified by Frederick Fried as the last stage in a wood-carving tradition that traces back through the cigar-store Indian to the earliest American ship carvers.

114. The golden age of chivalry. 1903. Wood, painted. L. 18'.
Carved in the Samuel A. Robb workshop, New York City, for the Sebastian Wagon Company. Used as a float in Barnum & Bailey Circus parades.
(*National Gallery of Art, Washington, Index of American Design*)

115. Merry-go-round horse at a small American Legion carnival in Bellows Falls, Vermont. 1941. (*Farm Security Administration*)

The carousel figure, another folk form that Frederick Fried has studied, actually achieves its greatest popularity and broadest range of expression in the twentieth century. "Flying horses," or wooden steeds and chariots that revolve around a center pole, come to us from eighteenth-century France, but in the period following the Civil War, American models progressed from stiff, toylike forms to magnificently animated lifesize beasts (fig. 115). The popularity that the carousel enjoyed by the turn of the century can be glimpsed through the production figures of the major manufacturers; some boasted an annual output in the neighborhood of one hundred units with six or more mounts each! The evolution of the carousel horse to a brilliantly polychromed steed garnished with fanciful trappings is well recorded in the *Index of American Design*.

Traditional trade signs, both symbolic and representational, continue to be painted and carved in the twentieth century. Numerous urban and rural examples from the 1930s are to be found in the files of the Farm Security Administration, and more recently photographers like Nina Starr and Tamara Wasserman have also made extensive records of them. The figures most recently encountered now—shoes, fish, keys, eyeglasses, the barber's pole, and the druggist's mortar and pestle—are, in fact, exactly the same ones most commonly produced by eighteenth- and nineteenth-century sign makers. The form of any of these elements is only slowly modified, so that the late twentieth-century shoemaker's sign (plate 34) is very likely to depict a man's high shoe of a much earlier date. New materials have made some significant changes, however, especially the electrified barber pole and the neon signs that dominate the urban trade scene.

One group of folk forms with an especially broad range of twentieth-century expression comprises the very ephemeral snowman and the only slightly longer-lived scarecrow (fig. 116) and harvest figure. Once again, the Farm Security Administration files contain good examples of at least the first two of these, but more recent attention has been focused on them through the efforts of Ann Parker and Avon Neal. The harvest figure's (plate 35) history is somewhat dim, and its origin seems vaguely related to Halloween fantasy. The snowman and scarecrow both come to us with a wealth of historic documentation and a well-defined traditional form. Although the overall design of these figures remains constant, late twentieth-century examples incorporate significant new details— snowmen with charcoal briquets instead of lumps of coal for eyes, scarecrows with heads made of inverted plastic detergent bottles and aluminum pie-plate hats.

If the twentieth century offers abundant examples of such anonymous popular art to anyone who looks above or beyond the hard surface of the modern street or highway, it is equally rich in examples of painting and sculpture by individuals who forge an artistic vocabulary with little or no reference to prevailing taste or artistic practice. Most celebrated of these is Anna Mary Robertson ("Grandma") Moses (1860–1961), who began painting in upper New York State at the age of seventy-seven and for almost a quarter of a century celebrated the rural past of her childhood in a plentiful series of intricately worked and highly detailed paintings. Less popularly acclaimed, but with solid recognition from the current art world, are artists like John Kane (1860–1934) of Pittsburgh, whose insistently symmetrical self-portrait in the collection of The Museum of Modern Art is probably a key work in the development of American Neorealism; Olof Krans (1838–1916), the Swedish-born housepainter, who recorded the communal religious life of Bishop Hill, Illinois; and Joseph Pickett (1848–1918), the general storekeeper of New Hope, Pennsylvania, whose few surviving works depict the local landscape as well as incidents in the American Revolution.

The phenomenon of the elderly would-be painter who, like Grandma Moses, successfully invents a mode of graphic expression despite a lack of formal training, is a recurrent one in the twentieth century. Sidney Janis called attention to it in the early 1940s, and more recently it has been copiously documented in *Twentieth-Century American Folk Art and Artists* by Herbert W. Hemphill, Jr., and Julia Weissman. One of the better known examples is Morris Hirshfield (1872–1946), who began painting after retirement from coat and slipper manufacturing in New York City and evolved a decorative form of linear repetition (fig. 117) that has suggested to some critics an origin in needlework. Another is J. O. J.

116. Scarecrow.
Rural North Carolina.
1938. (*Farm
Security Administration*)

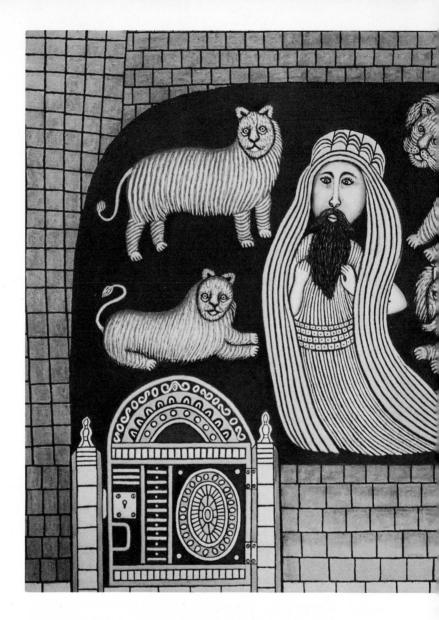

Frost (1852–1928) of Marblehead, Massachusetts, who at the age of sixty-eight set about depicting the details of his own youth at sea and the history of his native village. Others are Isidor ("Grand Pa" or "Pop") Wiener (1886–1970), who explored memories of

117. *Daniel in the Lions' Den.*
Morris Hirshfield. 1944.
Oil on canvas. 33″ × 39″.
(*Courtesy Sidney Janis Gallery*)

a Moldavian childhood and invented a biblical menagerie that found expression in plastic wood as well as in paint, and Sophy Regensburg (1885–1974), who developed a rigidly frontal style of still-life painting.

Some other twentieth-century folk artists share the qualities of personal eccentricity or social isolation. Henry Church (1836–1908) of Chagrin Falls, Ohio, is an early example of the phenomenon; he abandoned a prosperous family blacksmith trade at the age of forty-two to devote himself to a life of painting, sculpture, and hunting that ultimately alienated him from the surrounding community. The few remaining examples of his painting involve a complicated symbolism expressed in composition as well as in clearly stated and hidden figures. Another is Simon Rodia (1879–1965), who began construction of the celebrated Watts Towers in Los Angeles in 1921 (fig. 118) and became progressively more reclusive as his fantastic constructions developed during the ensuing thirty-three years—after which he literally disappeared. Others are Justin McCarthy (born c. 1891), a recluse of Weatherly, Pennsylvania, who began to paint in 1920, using bold flat forms that seem to be related to German Expressionist and Fauve art which he had seen in his youth on a trip to Paris; and Joseph E. Yoakum (born 1888), who paints landscapes (plate 36) that bring a somewhat Blake-like fantasy to scenes recalled from world travels as a hobo and stowaway.

118. *Watts Towers*. Simon Rodia. Los Angeles, California. Begun 1921, completed 1954. Steel rods, mesh, and mortar decorated with broken bottles, dishes, tiles, and seashells. The complex includes towers, arches, fountains, pavilions, and labyrinths built without predrawn designs, machinery, or scaffolding. Photograph courtesy James Eakle.

The nineteenth-century folk-art vision has sometimes been explained as the product of rural isolation. The twentieth-century folk artist, however, is more likely than not to develop a pictorial language to deal with the urban scene. The form and life of the city are dealt with by Pittsburgh's John Kane and by Joseph Fracarossi (1914–1970), Ralph Fasanella (born 1914), and Vestie E. Davis (born 1904), all of New York City. And other twentieth-century folk artists, like Patrick J. Sullivan (1894–1967) of Wheeling, West Virginia, and Maceptaw Bogun (born 1917) of New York City, invent original symbolic schemes although, as city dwellers, they had ready access to prevailing means of pictorial communication.

Far from stifling original artistic vision with photography, television, and mass-produced pictorial publications, the twentieth century seems to have encouraged its expression in infinite variety. In addition to abundant painting and drawing, we can find it in sculpture in the work of people like Will Edmondson (1868–1951), who began stone-carving in his native Nashville, Tennessee, after a truckload of limestone paving block was abandoned in his driveway; and Edgar Tolson (born c. 1905), the Appalachian preacher, farmer, and itinerant worker, who has evolved a biblical world inhabited by tube-shaped, wall-eyed figures (fig. 119) carved from native poplar wood. We can find it in monumental environmental projects like Rodia's Los Angeles towers, the Wilson, Kansas, farm gardens of Ed Root (1868–1959), in Concrete Park (plate 37) built in Phillips, Wisconsin, by Fred Smith (born 1886), or in the Garden of Eden and Modern Civilization built in Lucas, Kansas, by S. P. Dinsmoor (1843–1932).

Free from the social and economic limitations that the conventional study and practice of art imposes, we find the folk artist

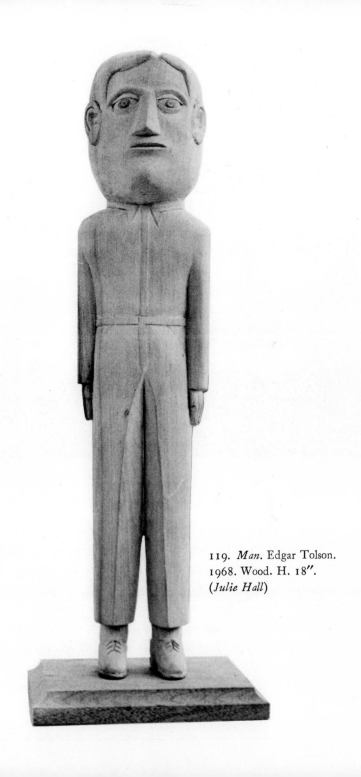

119. *Man*. Edgar Tolson.
1968. Wood. H. 18″.
(*Julie Hall*)

120. Neon shop sign. York Avenue and 84th Street, New York. 1973. (*Photograph courtesy M. J. Gladstone*)

emerging from every conceivable occupational group (fig. 120) and from an apparently limitless range of ethnicity. It is this freedom that undoubtedly accounts for the large number of black folk artists of acknowledged achievement. In addition to figures of national and international prominence like Will Edmondson and Horace Pippin (born 1888, fig. 121), we can find a rich vein of black folk expression in the work of artists like the New Orleans Gospel singer Sister Gertrude Morgan (born 1900), the Melrose Plantation pictures made near Natchitoches, Louisiana, by Clementine Hunter

(born c. 1882), and the paintings of Minnie Evans (born 1893) of Wilmington, North Carolina, whose sinuous forms involve an apparently unconscious Freudian symbolism.

All of these artists continue in a tradition of aesthetic independence that the 1930s recognized and celebrated. They are not popular artists in the sense that their aims are probably not apparent to any eye other than an art-conscious one. They are not naïve if they know about the established art of the twentieth century—which many of them do. They are not primitive if they have evolved a

121. *Buffalo Hunt*. Horace Pippin. 1933.
Oil on canvas. 21¼″ × 31″.
(*Whitney Museum of American Art*)

refined and specialized means of communication—which all of them have done. After four decades of looking and collecting and studying, we have little to add to the 1930s definition of what folk art is, but we can say very emphatically that it is alive as the twentieth century progresses.

FURTHER READING

BISHOP, ROBERT. *American Folk Sculpture*. New York: E. P. Dutton & Co., 1974.

CAHILL, HOLGER. *American Folk Art: The Art of the Common Man in America 1750–1900*. New York: W. W. Norton & Co. for The Museum of Modern Art, 1932.

CHRISTENSEN, ERWIN. *The Index of American Design*. Washington, D.C.: National Gallery of Art, 1950.

FITZGERALD, KEN. *Weathervanes and Whirligigs*. New York: Clarkson N. Potter, 1967.

FRIED, FREDERICK. *Artists in Wood*. New York: Clarkson N. Potter, 1970.
———. *A Pictorial History of the Carousel*. New York: A. S. Barnes & Co., 1964.

GLADSTONE, M. J. *A Carrot for a Nose; the Form of Folk Sculpture on America's City Streets and Country Roads*. New York: Charles Scribner's Sons, 1974.

HEMPHILL, HERBERT W., JR., and WEISSMAN, JULIA. *Twentieth-Century American Folk Art and Artists*. New York: E. P. Dutton & Co., 1974.

HORNUNG, CLARENCE P. *Treasury of American Design*. 2 vols. New York: Harry N. Abrams, Inc., n.d.

JANIS, SIDNEY. *They Taught Themselves; American Primitive Painters of the Twentieth Century*. New York: The Dial Press, 1942.

KALLIR, OTTO, ed. *Grandma Moses, My Life's History*. New York: Harper & Row, 1952.

KANE, JOHN. *Sky Hooks: The Autobiography of John Kane.* Notes and post-script by Mary McSwigan. Philadelphia: J. B. Lippincott Co., 1938.

PARKER, ANN, and NEAL, AVON. *Ephemeral Folk Figures.* New York: Clarkson N. Potter, 1969.

INDEX